for Ina and Jonah

THE WEST OF IRELAND

a photographer's journey

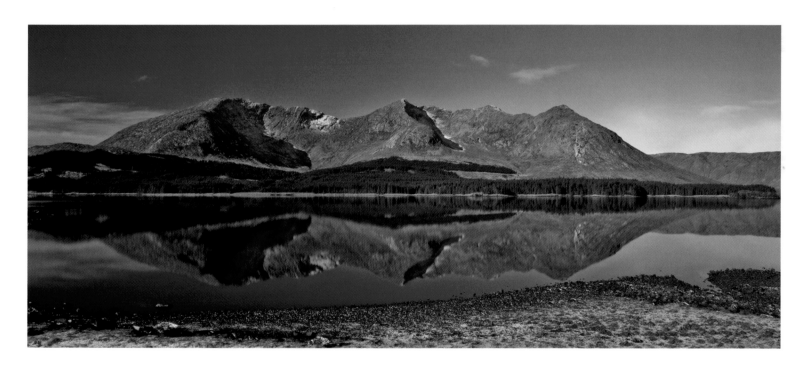

Carsten Krieger

The Collins Press

First published in 2009 by
The Collins Press
West Link Park
Doughcloyne
Wilton
Cork

This book is not intended as an aid to navigation.
The author and publisher disclaim any responsibility for errors regarding light character.

British Library Cataloguing in Publication Data
Krieger, Carsten
The west of Ireland : a photographer's journey
1. Krieger, Carsten 2. Landscape photography 3. Ireland - Pictorial works
I. Title
914.1'5'00222
ISBN-13: 9781905172894

Design and typesetting: Carsten Krieger

Fonts: Minion Pro, TRAJAN PRO, Lucida Sans

Printed in China by PrintWORKS

This publication has received support from the Heritage Council under the 2009 Publications Grant Scheme

page 1: WINTER SUNSET, Moore Bay, County Clare
page 3: LOUGH INAGH & TWELVE BENS, Connemara, County Galway
page 5: GLENTEENASSIG, Dingle Peninsula, County Kerry

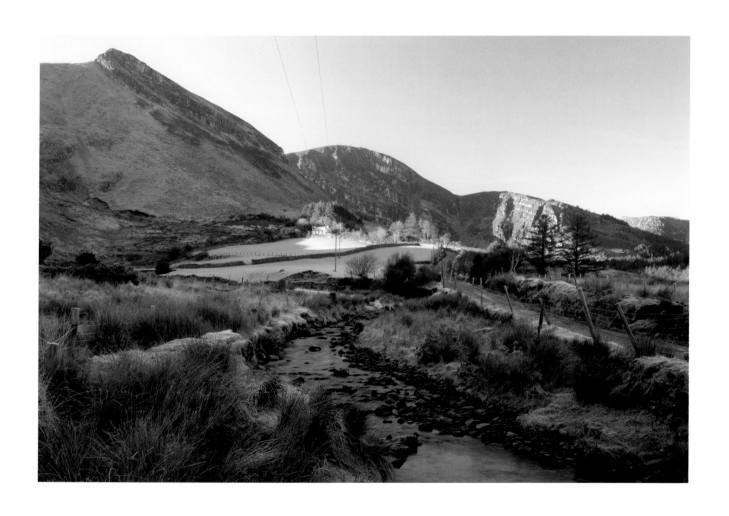

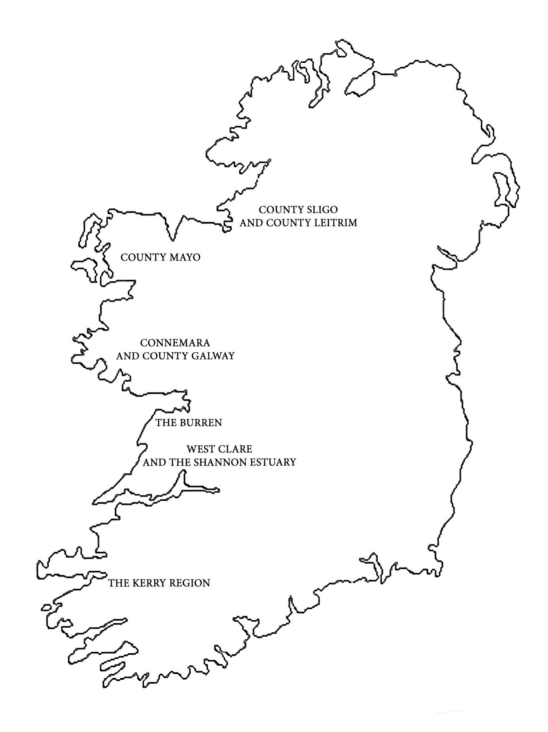

CONTENTS

Introduction 8

The garden of the West: the Kerry Region 10

Where the river meets the sea: west Clare and the Shannon Estuary 44

Limestone country: the Burren 64

The Heart of the West: Connemara and County Galway 82

From Delphi to Downpatrick Head: In County Mayo 112

Hidden treasures: County Sligo and County Leitrim 144

INTRODUCTION

When I was ten years old I read *The Lord of the Rings* for the first time. One thing about this book that fascinated me, apart from the story and its characters, was the vivid and detailed description of the setting, the glorious and wild landscape of Middle Earth. A few years later I learned that J. R. R. Tolkien got much of his inspiration for Middle Earth in the west of Ireland where he regularly spent his holidays. In my own juvenile imagination Ireland became Middle Earth, a faraway land of majestic mountains, enchanting forests, wild rivers and tranquil lakes. A decade after my first encounter with Frodo and his homeland I finally made the trip to the island that supposedly was the alter ego of Middle Earth.

On a cold spring afternoon I found myself in Cahersiveen, a small village on the Iveragh Peninsula in County Kerry. A fine drizzle and the smell of turf fires filled the air. The day before I had seen the Atlantic Ocean for the first time in my life and the image of the snow-capped MacGillycuddy's Reeks was still in my mind. A cup of hot milky tea and a chat that I would enjoy despite my broken English were waiting for me in the next pub. Like many before me I had fallen in love with this small island on the edge of Europe. Over the following years I regularly travelled to Ireland and my journeys sooner or later always brought me back to the west of the country.

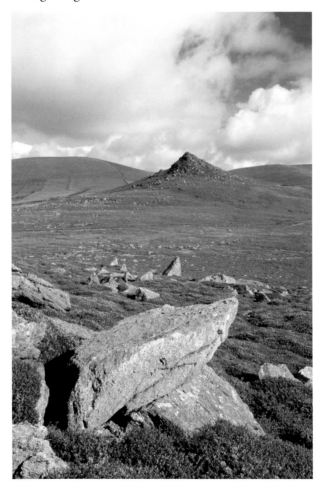

The west of Ireland is considered one of the last unspoiled and most beautiful parts of Europe. Indeed the scenery that awaits the visitor could not be more breathtaking and diverse. A wild coastline with sheer cliffs and sandy beaches, towering mountain ranges and green valleys, rivers, streams and tranquil lakes, wild bogs and ancient forests, all confined to an area that can be travelled within a day's journey.

Although this landscape seems to be untouched and almost virginal it is anything but this. Man has shaped the west of Ireland since early Neolithic times and the reminders are everywhere. The biggest impact on the appearance of the landscape today was the clearing of native forests by the early settlers for their farming activities. Over time this deforestation in combination with a change to a wetter climate supported the growth of the bogs, which are a prominent feature of the Irish landscape today. More obvious signs of human presence are the buildings that have stood the test of time.

Burial sites with cairns and tombs, defensive settlements like ringforts and tower houses, the ubiquitous stone walls and the countless ruins of abandoned cottages are proof of a long and rich history. Although man-made, these structures have become an integral part of the landscape and Ireland would not be the same without them.

Unfortunately the modern world has also left its impact in the more recent past. Roads dissect the landscape, modern housing developments have appeared in even the remotest and most picturesque areas, boglands have been destroyed by commercial peat harvesting, forests are used as dumps, lakes and rivers are getting more and more polluted, the flotsam and jetsam of our highly developed society is scattered on the beaches.

For a landscape photographer these blemishes can become very obtrusive. For some strange reason an ancient stonewall or the ruins of an old cottage make a wonderful addition to a landscape picture. A barbed wired fence or a modern bungalow, however, do not have the same effect. This book is an attempt to capture the west of Ireland as I experienced it on my first visit all those years ago when the mountains of Kerry looked very much like the Misty Mountains of Middle Earth.

Landscape photography in Ireland can be extremely rewarding and deeply frustrating. The Irish weather has a tendency to be very unpredictable and being in the right place at the right time involves, besides a good deal of planning, an equal amount of luck. Watching the weather forecast becomes routine although most of the time it turns out to be wrong for where you intend to take your pictures. There were days when I did not even get the camera out of the bag and, having driven for several hours to a location, this can be very frustrating. On the other hand, there are those rare occasions when everything falls into place and the weather, landscape and inspiration all interact in perfect harmony.

One of those memorable moments happened in and around the Inagh Valley in Connemara in the middle of winter. I was staying with friends in Maum and set out very early in the morning. The evening before had been very unpleasant with gale-force winds and constant rain and hail showers. My expectations were understandably low. However, sometime during the night, it must have started to snow and while I was heading to the Inagh Valley I saw a winter wonderland appear out of the darkness.

I made my first picture that morning well before sunrise at the shores of Derryclare Lough, which is probably one of the most photographed locations in Connemara. The conditions that morning, however, were unusual and would give this well-known place the edge I was looking for. By the time I packed up I knew I had something special and this image alone would make my day. However, it got even better. The clouds began to clear and I reached Lough Inagh just in time for sunrise. I could not believe my luck when the Twelve Bens started to glow red under the first rays of the rising sun while the shore of Lough Inagh was still covered in snow. I was spellbound and for the rest of the morning I worked my way up and down the valley.

If the conditions are right the average landscape photographer creates probably three or four images a week that are good enough for publication. On this single morning I was able to make five pictures that made it into this book. What a day!

left: CLOGHER HEAD, Dingle Peninsula, County Kerry

THE GARDEN OF THE WEST

THE KERRY REGION

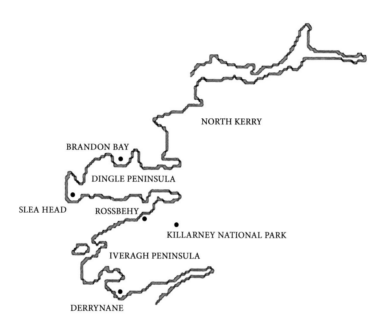

NORTH KERRY

BRANDON BAY

DINGLE PENINSULA

SLEA HEAD ROSSBEHY

KILLARNEY NATIONAL PARK

IVERAGH PENINSULA

DERRYNANE

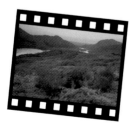
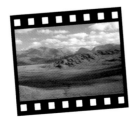

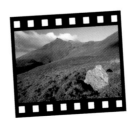

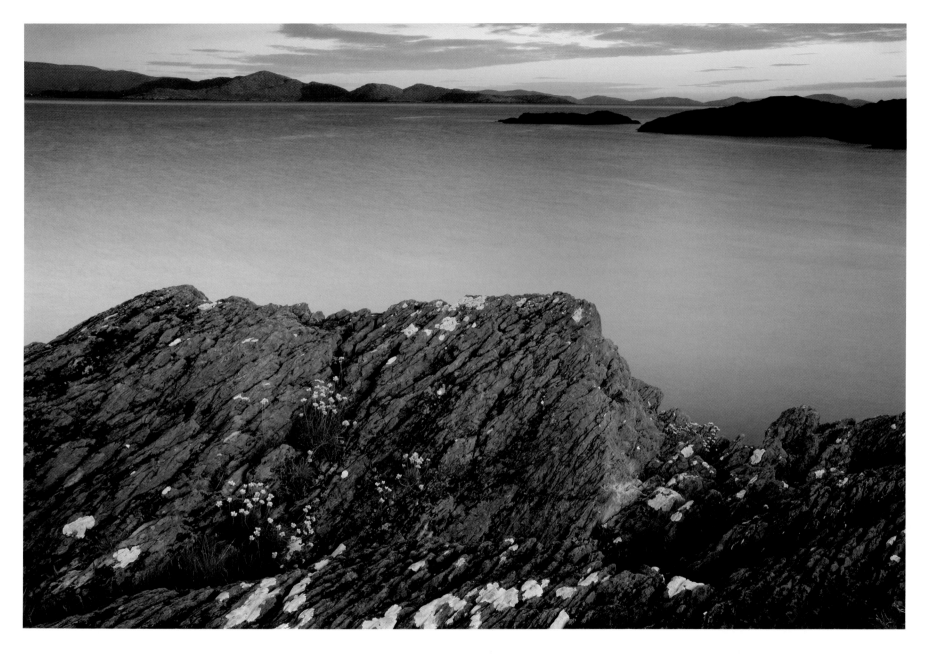

BEARA VIEW
Kenmare River, Illauncrone, Iveragh Peninsula

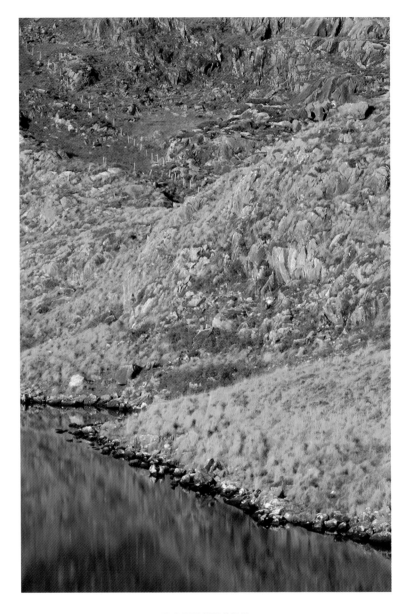

LAKESHORE
Barfinnihy Lough, Iveragh Peninsula

There is something special about the Kingdom of Kerry, especially the south of the county which is blessed with spectacular beauty.

The Iveragh Peninsula, better known as the Ring of Kerry, and the Dingle Peninsula are a perfect combination of majestic mountains, sparkling lakes, ancient forests and a diverse coastline. If there is a Garden of Eden I imagine it looks like this.

The north of Kerry stretches between Tralee Bay and the mouth of the Shannon and could not be more different. Instead of mountains there is a flat patchwork of fields dotted with cozy villages. The straight coastline features a string of long sandy beaches and some of Ireland's most popular seaside resorts.

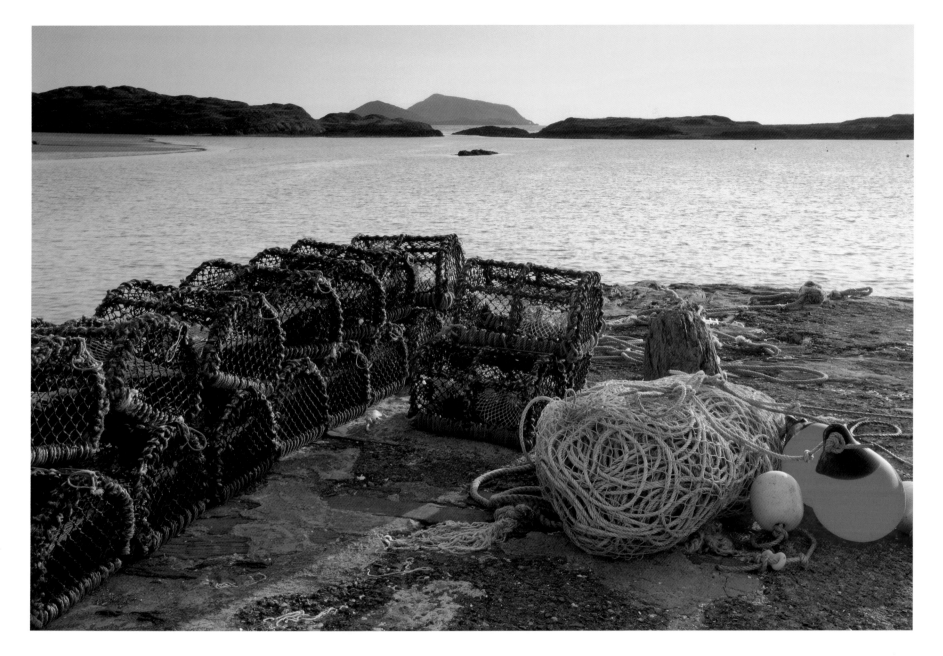

DERRYNANE QUAY

Derrynane Harbour, Iveragh Peninsula

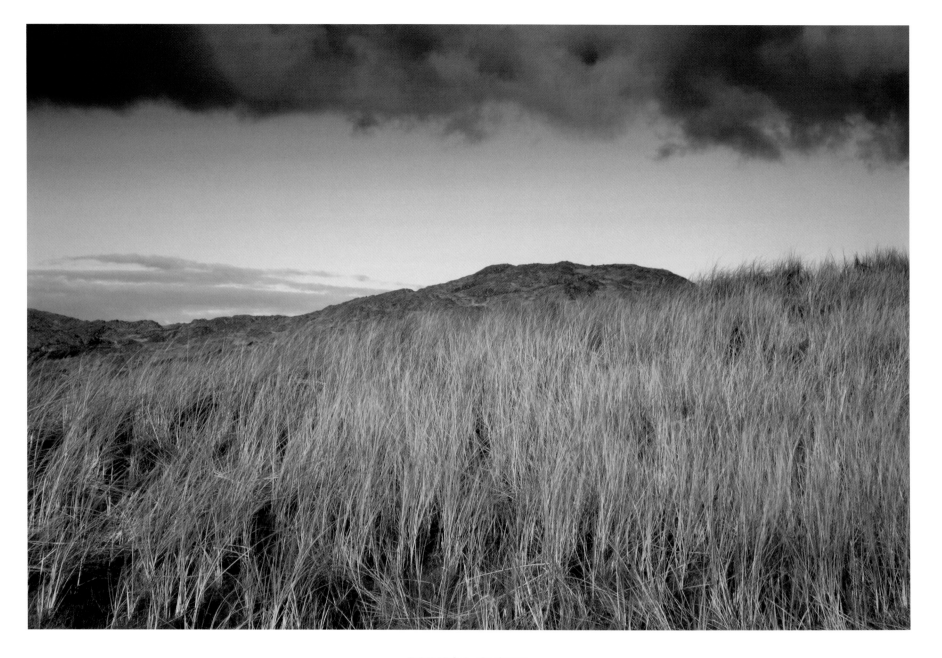

DUNES & CLOUD
Derrynane, Iveragh Peninsula

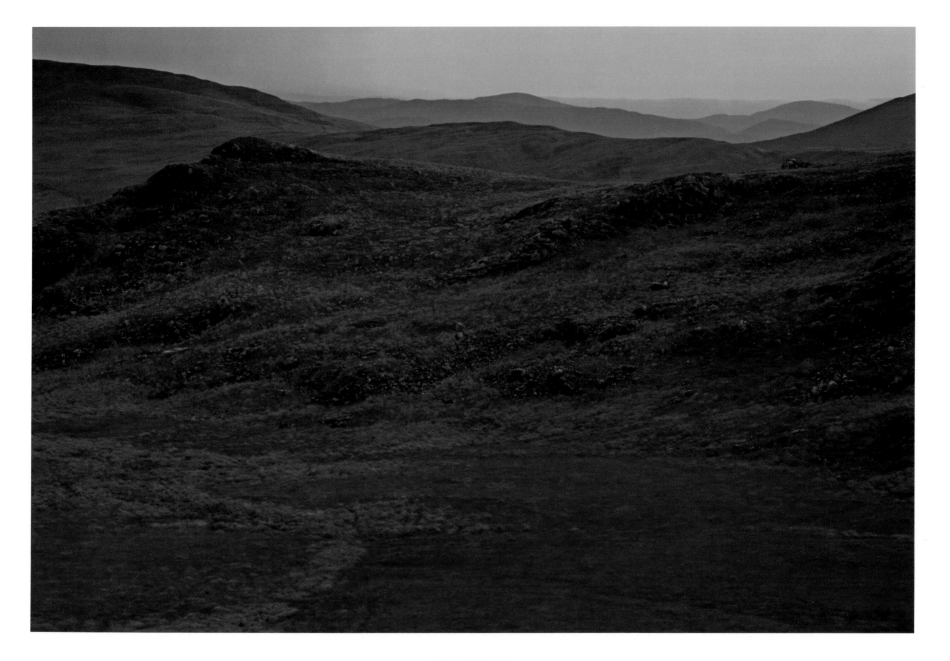

NIGHTFALL
Moll's Gap, Iveragh Peninsula

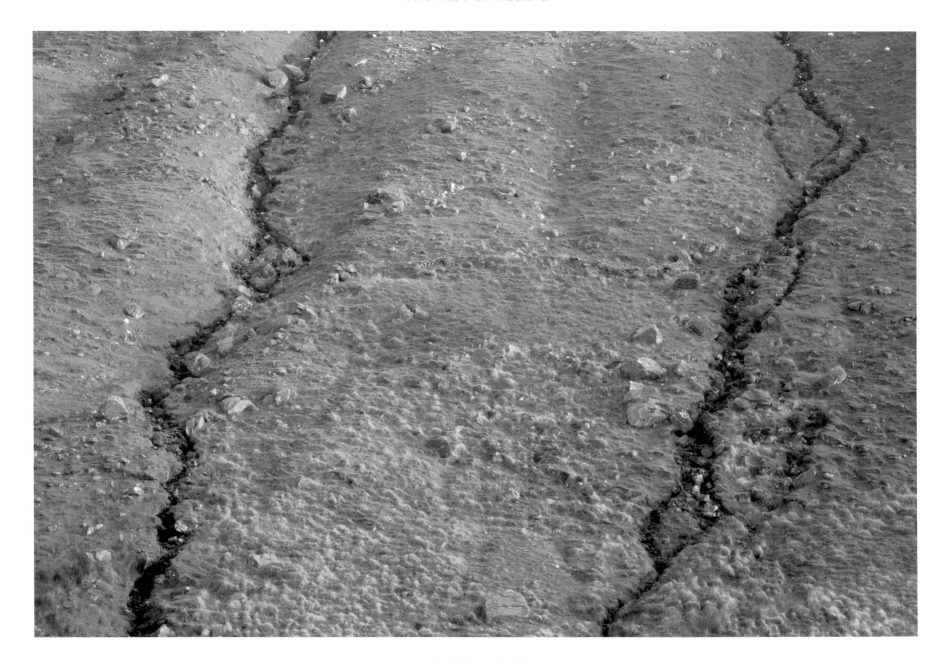

MOUNTAINSIDE
Inchinglanna, Iveragh Peninsula

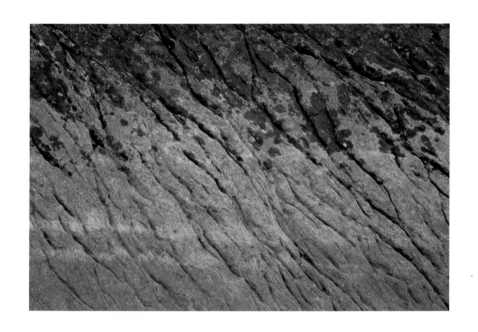

KERRY SANDSTONE I
Derrynane Bay, Iveragh Peninsula

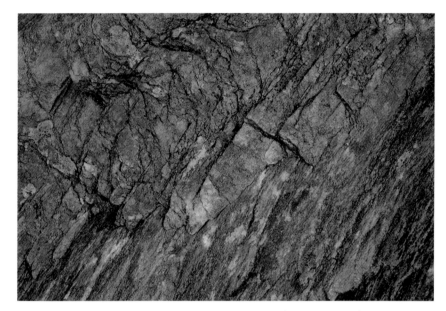

KERRY SANDSTONE II
Ballaghbeama Gap, Iveragh Peninsula

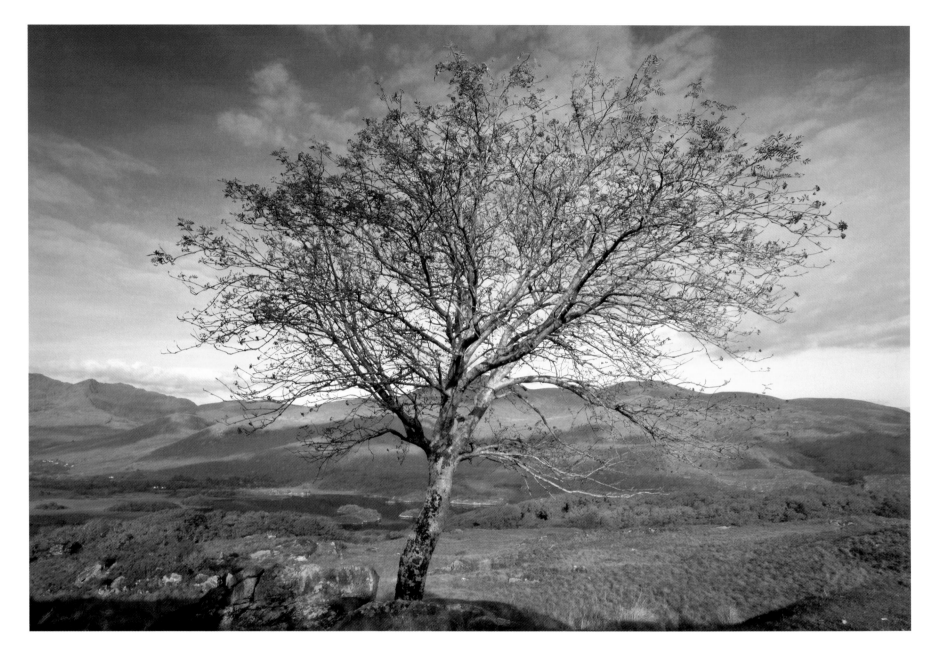

ROWAN TREE
Ladies' View, Killarney National Park

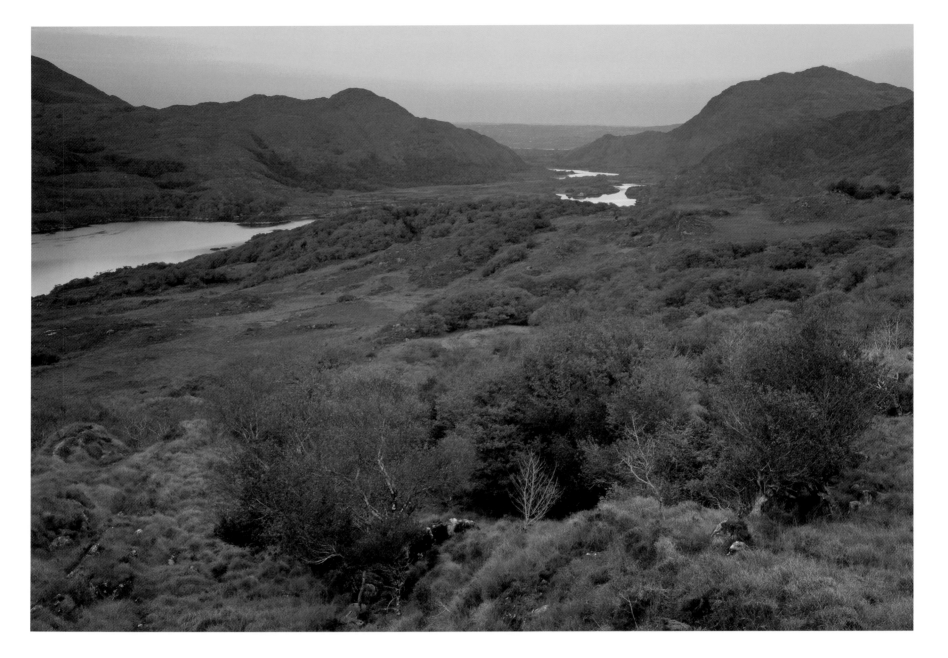

LADIES' VIEW
Cahernabane, Killarney National Park

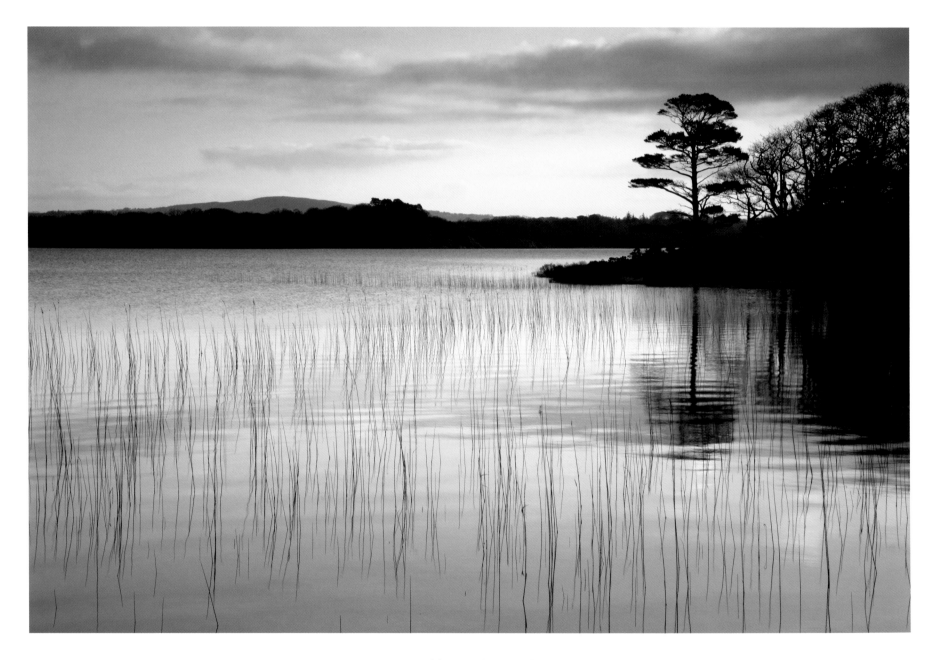

WINTER MORNING
Muckross Lake, Bog Bay, Killarney National Park

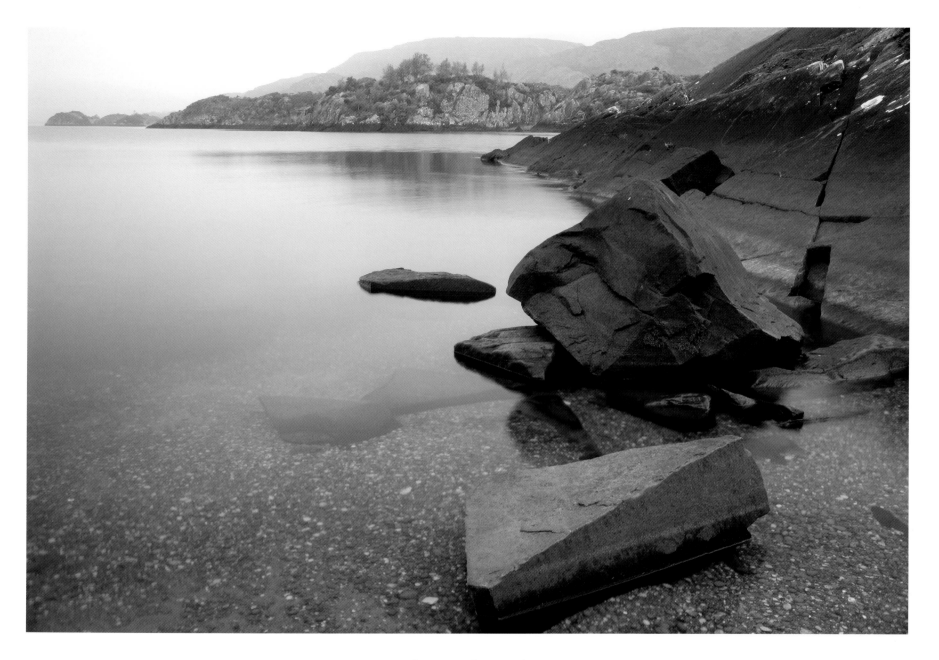

CALM MORNING
Upper Lake, Killarney National Park

The lakes of Killarney are part of Killarney National Park and attract thousands of visitors every year. Lough Leane, Muckross Lake and the Upper Lake are all interconnected and lie in a mountain-ringed valley. This landscape seems to have come right out of a fairytale. The lakes, forests and mountains can only be described as magical and every time I return here I fall under their spell. Working in Killarney National Park is pure pleasure and all a humble landscape photographer could ask for.

The park was the first Irish National Park and was established in 1932. Since then the Killarney National Park has been extended considerably and today it is more important than ever as it holds a unique combination of habitats with an equally unique flora and fauna. The park has the only remaining wild herd of red deer in Ireland, the last extensive remains of native Irish oak forest and one of the few pure yew forests in Europe. Some of the yew trees growing in Reenadinna Wood on the Muckross Peninsula are more than 200 years old.

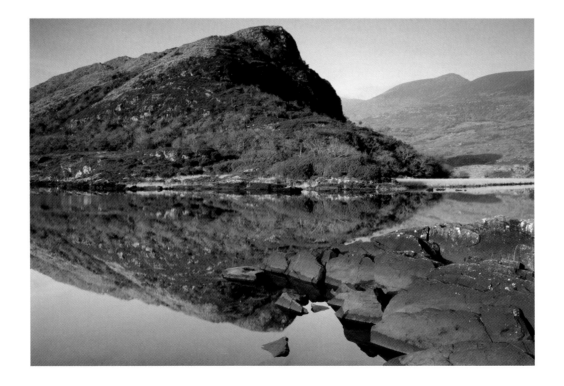

EAGLE'S NEST
The Long Range, Killarney National Park

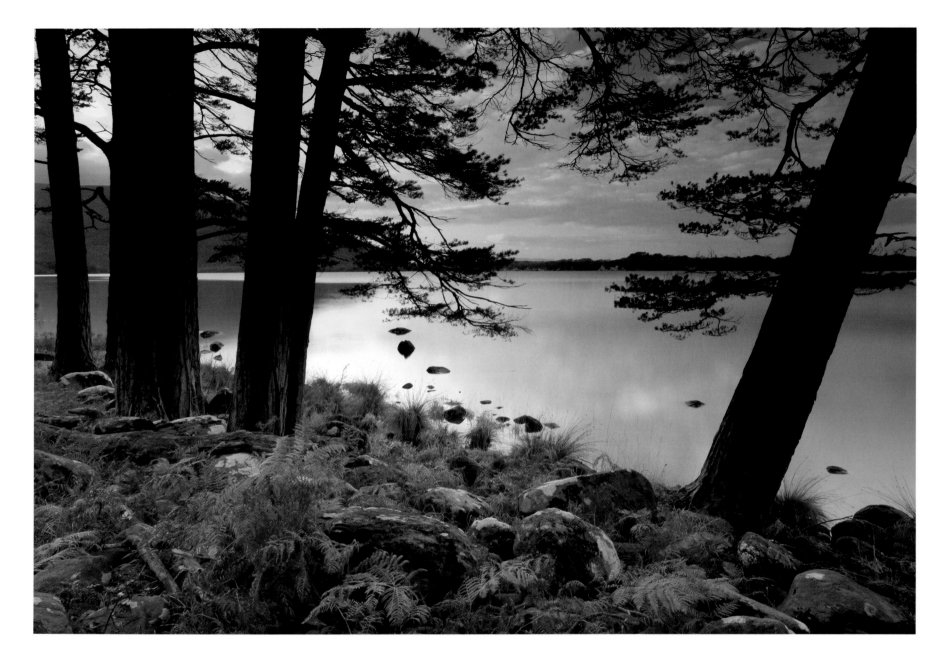

LAKESIDE EVENING
Lough Leane, Castlelough Bay, Killarney National Park

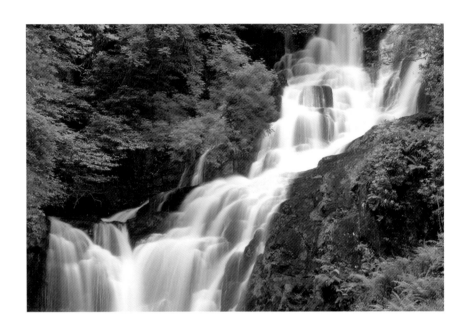

TORC WATERFALL
Killarney National Park

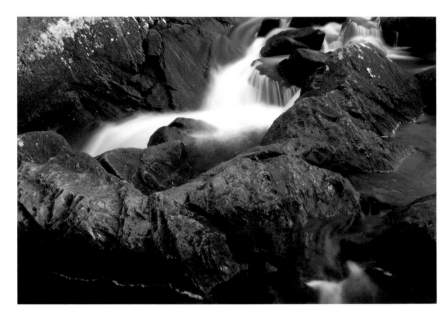

CASCADE
Galway's River, Killarney National Park

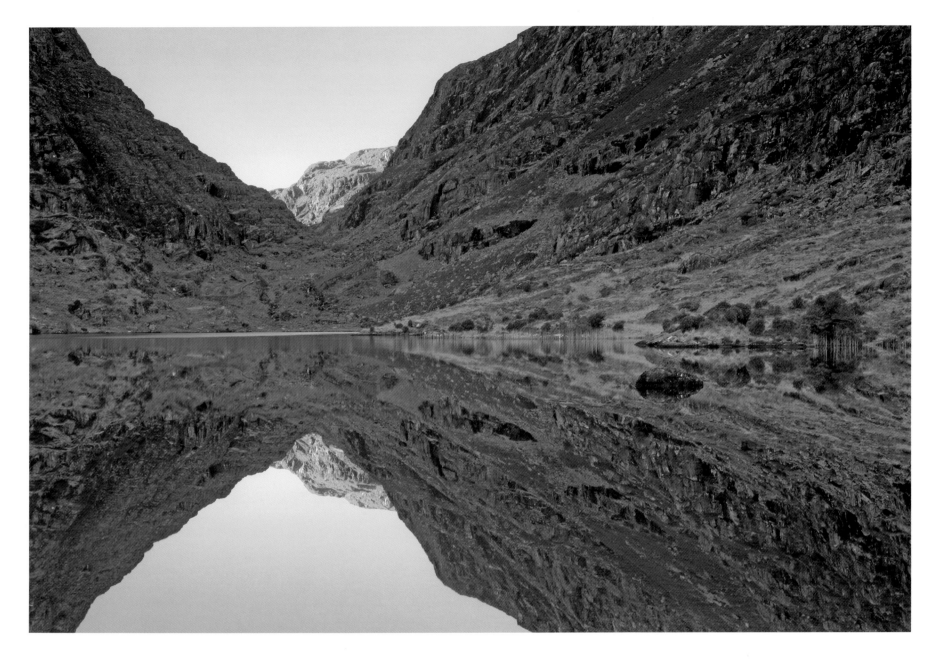

PERFECT REFLECTION
Gap of Dunloe, Auger Lake, Killarney

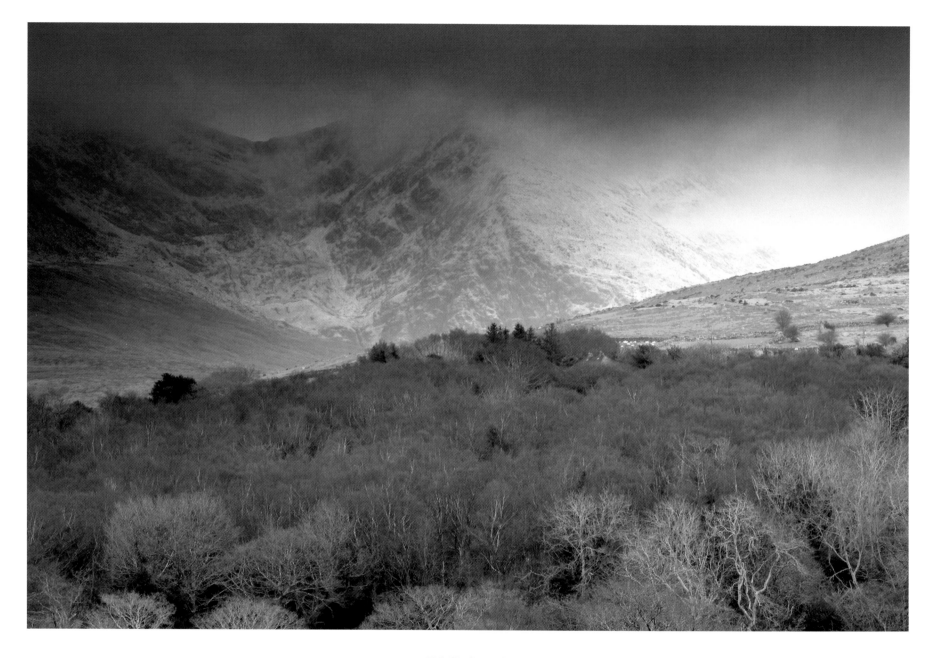

IN CLOUDS
Carrauntoohil, MacGillycuddy's Reeks, Iveragh Peninsula

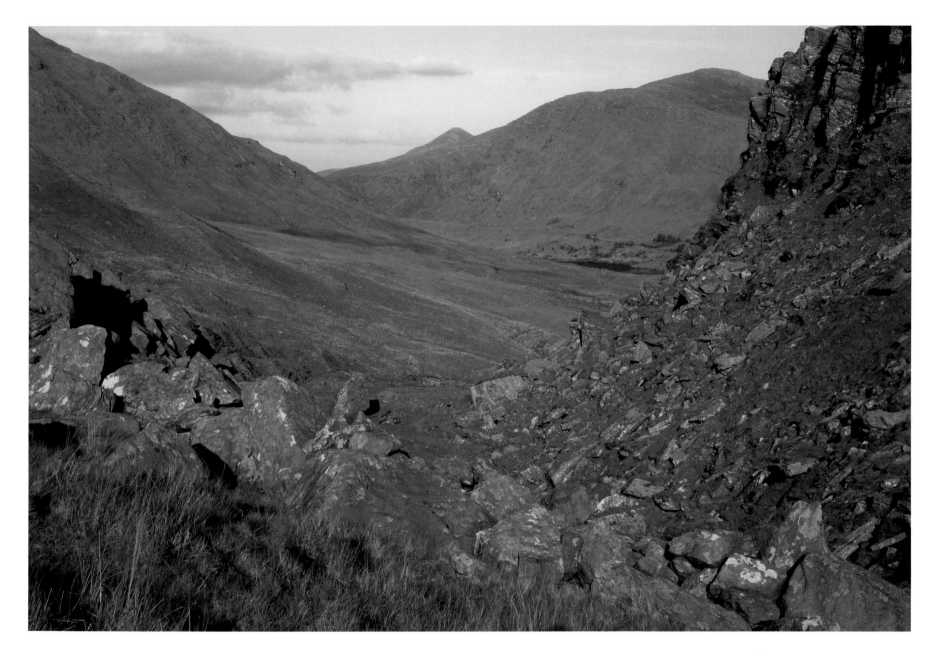

GREEN VALLEY
Ballaghbeama Gap, Iveragh Peninsula

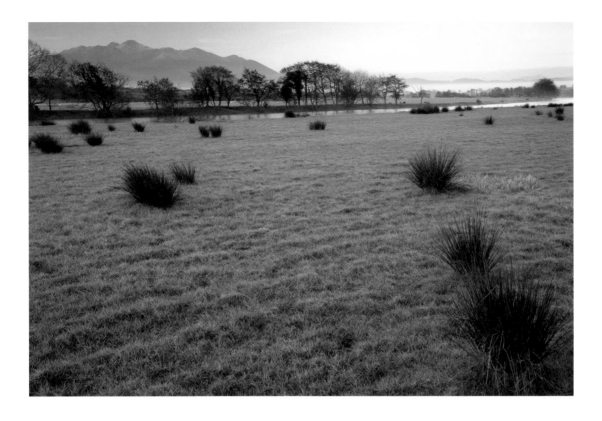

RIVER & MOUNTAINS
River Laune & MacGillycuddy's Reeks, Iveragh Peninsula

Kerry has the highest rainfall of any county in Ireland and the MacGillycuddy's Reeks are partly to blame for this, blocking weather fronts from the Atlantic which shed a lot of moisture here. The Reeks are the backbone of the Iveragh Peninsula, a mountain chain with some of the highest peaks in Ireland and Carrauntoohill, Ireland's highest mountain.

I have a weak spot for the MacGillycuddy's Reeks and I wanted to do them justice and show them in all their grandeur. A difficult task when most of the time they prefer to cover themselves in clouds. I had to wait two years to finally be able to take this image (right) of the Reeks from Ballaghisheen Pass on a cold but sunny day in November. I spent several hours on that windy mountain pass trying to get it right because the next chance for taking a picture like this might have been several years away.

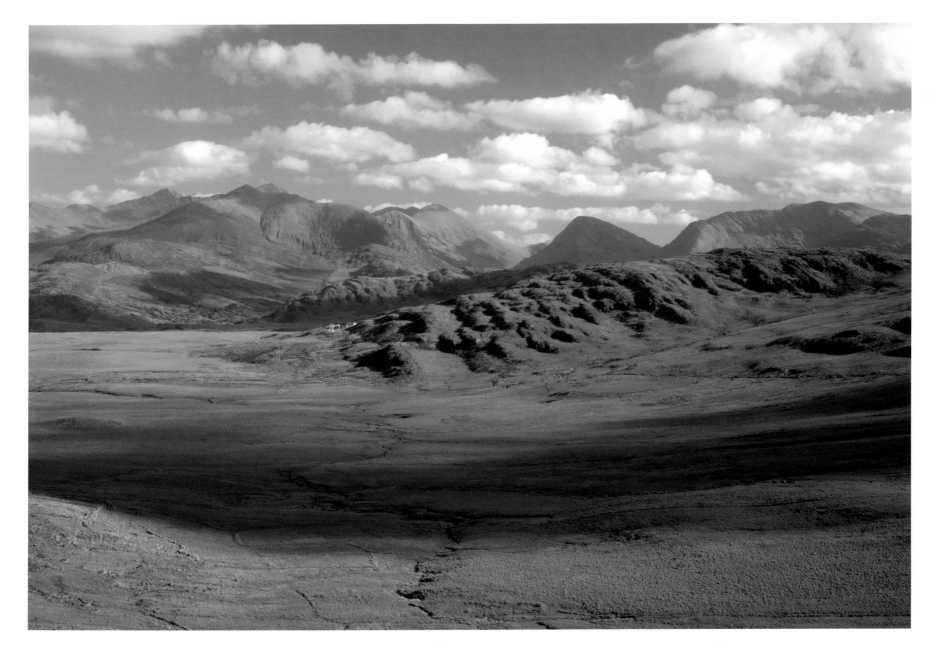

THE REEKS
MacGillycuddy's Reeks, Ballaghisheen, Iveragh Peninsula

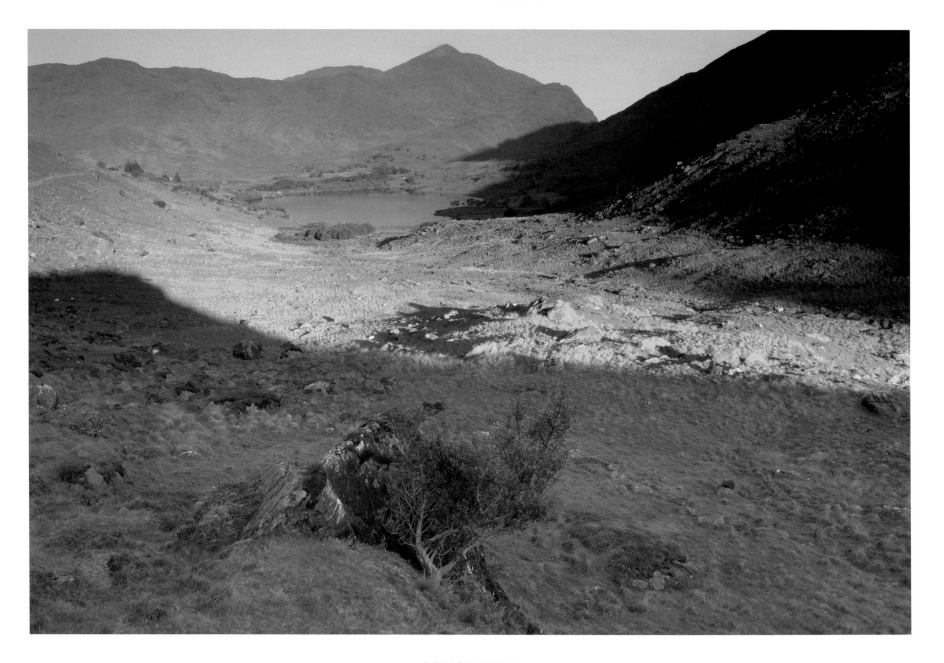

LOUGH BRIN
Inchinglanna, Iveragh Peninsula

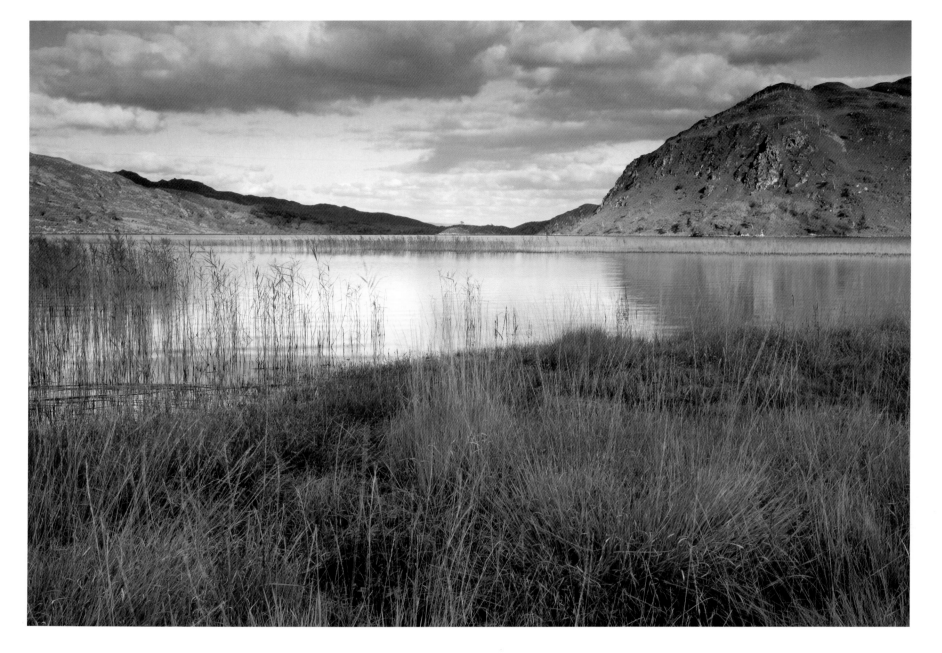

LOUGH CARAGH
Bunglasha, Iveragh Peninsula

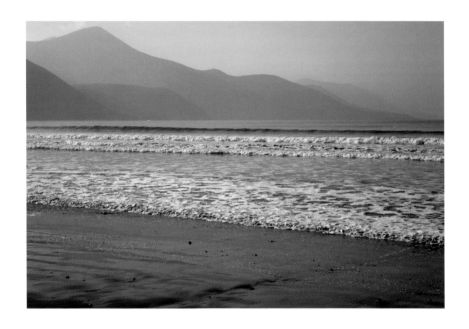

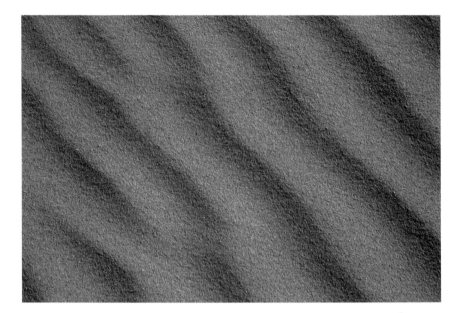

WHITE STRAND
Rossbehy, Iveragh Peninsula

SAND RIPPLES
Rossbehy, Iveragh Peninsula

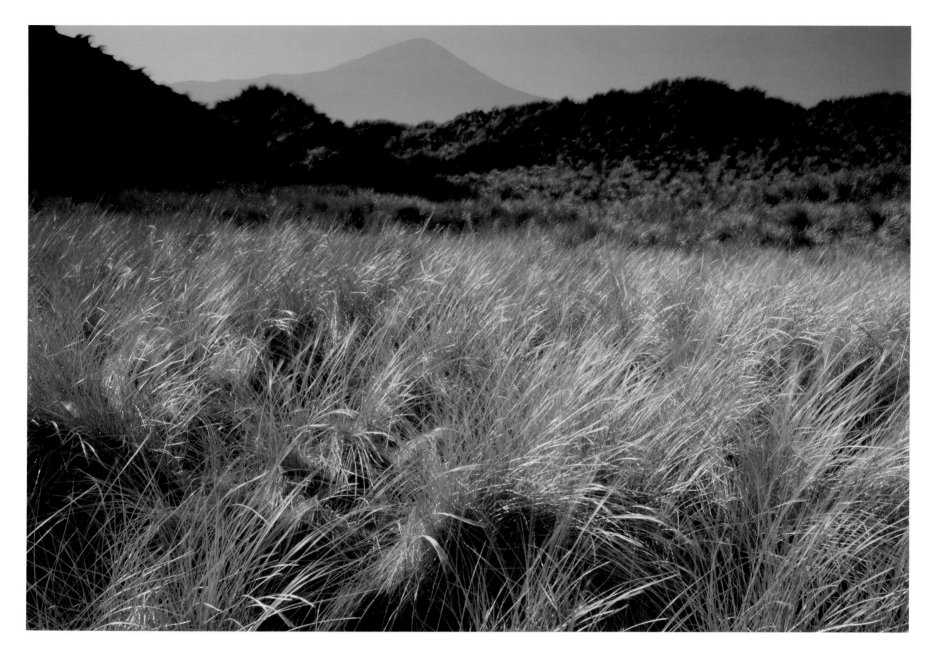

SUNSHINE ON DUNES
Rossbehy, Iveragh Peninsula

The Dingle Peninsula is mountain and ocean. It is no wonder then that it has some of Ireland's most beautiful beaches and the Dingle mountains are among the most majestic and highest peaks in Ireland.

Overlooking the Peninsula are Brandon Mountain and Brandon Peak, both named after St Brendan. Legend tells us that he and a handful of his monks left Dingle around 525 AD in a leather boat to sail to the Isle of Paradise. Instead, they made landfall in Newfoundland and discovered America well before Columbus. The explorer Tim Severin proved that the legend may be true by successfully making the journey in a similar boat in 1976. His book *The Brendan Voyage*, describing his experience of crossing the North Atlantic in a leather boat, is a highly fascinating and inspiring read.

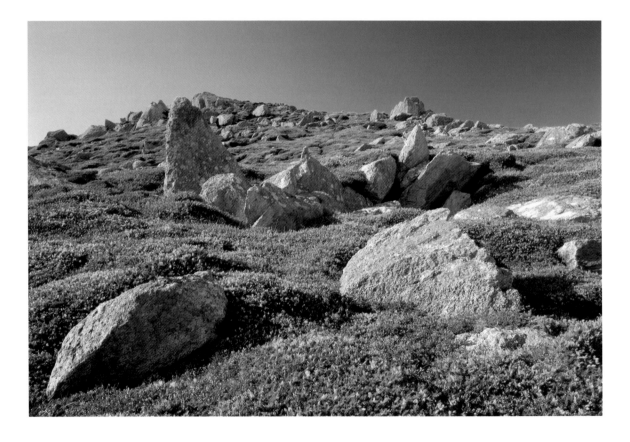

GORSE, HEATHER & ROCK
Clogher Head, Dingle Peninsula

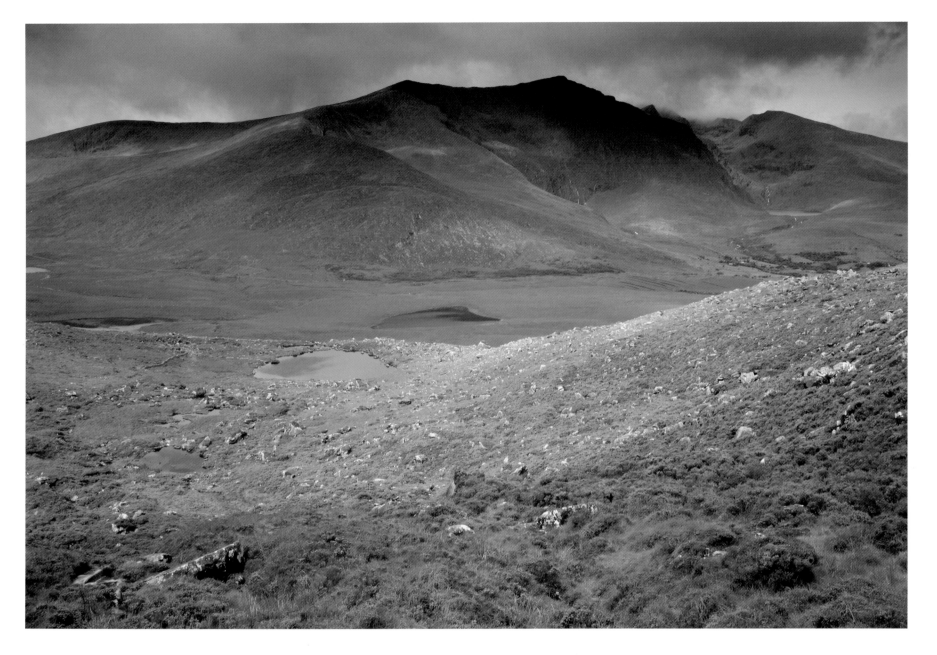

BRANDON VIEW
Conor Pass, Dingle Peninsula

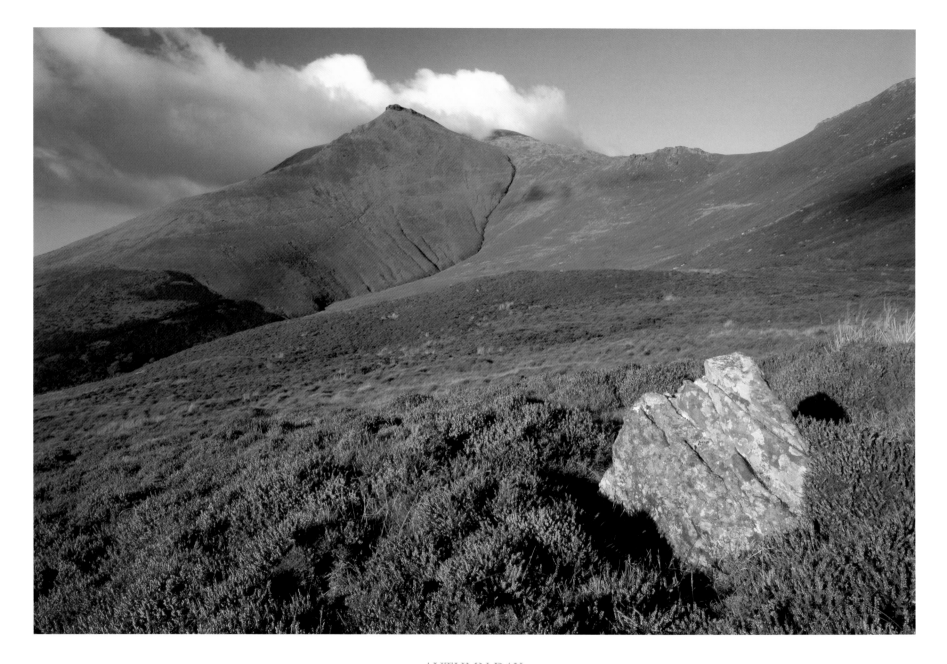

AUTUMN DAY
Slieve Mish Mountains, Dingle Peninsula

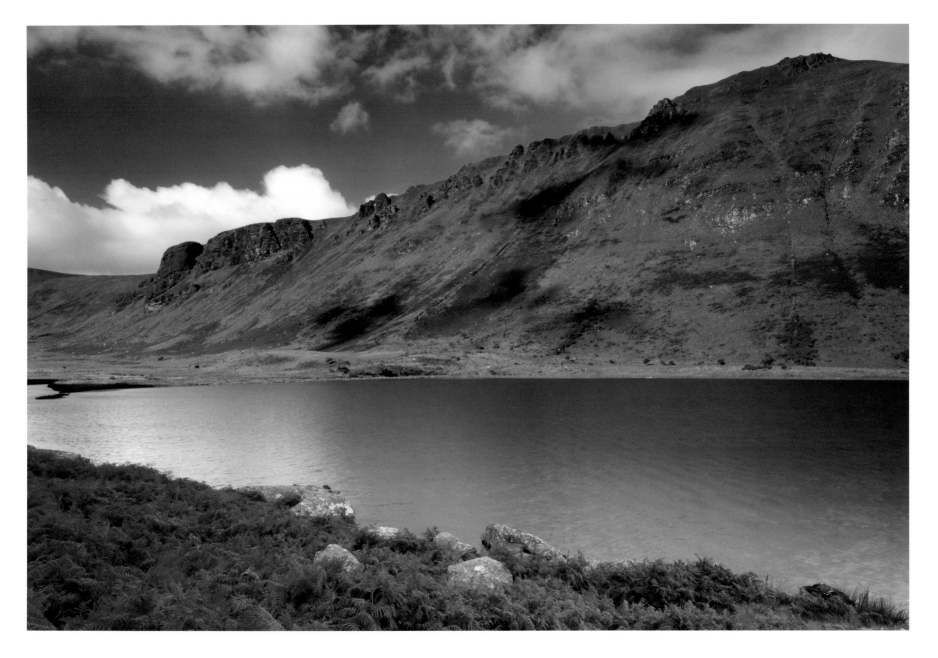

LOUGH ANASCAUL
Reamore, Dingle Peninsula

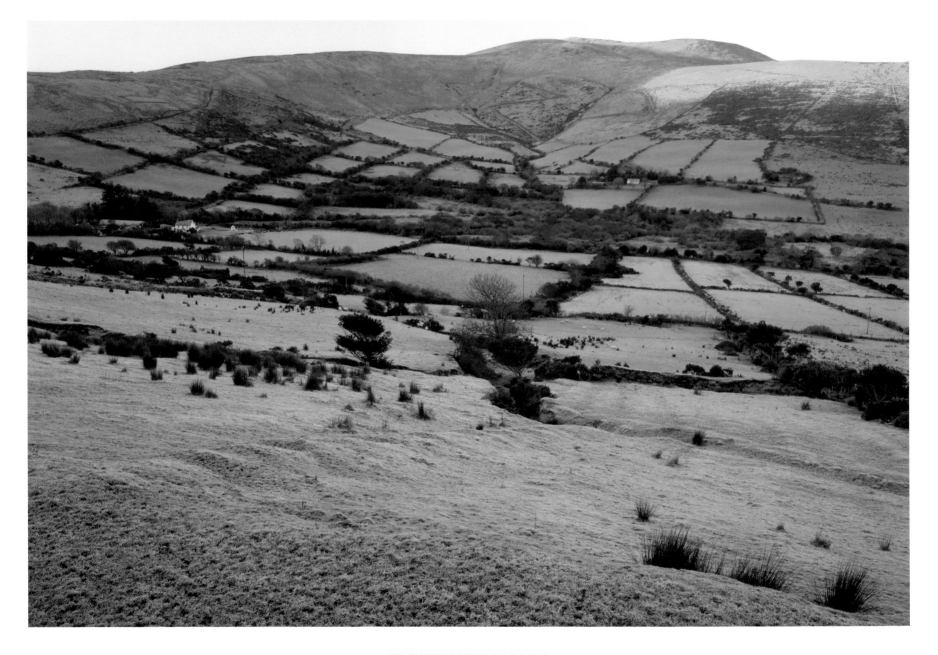

FROST IN THE VALLEY
Camp, Dingle Peninsula

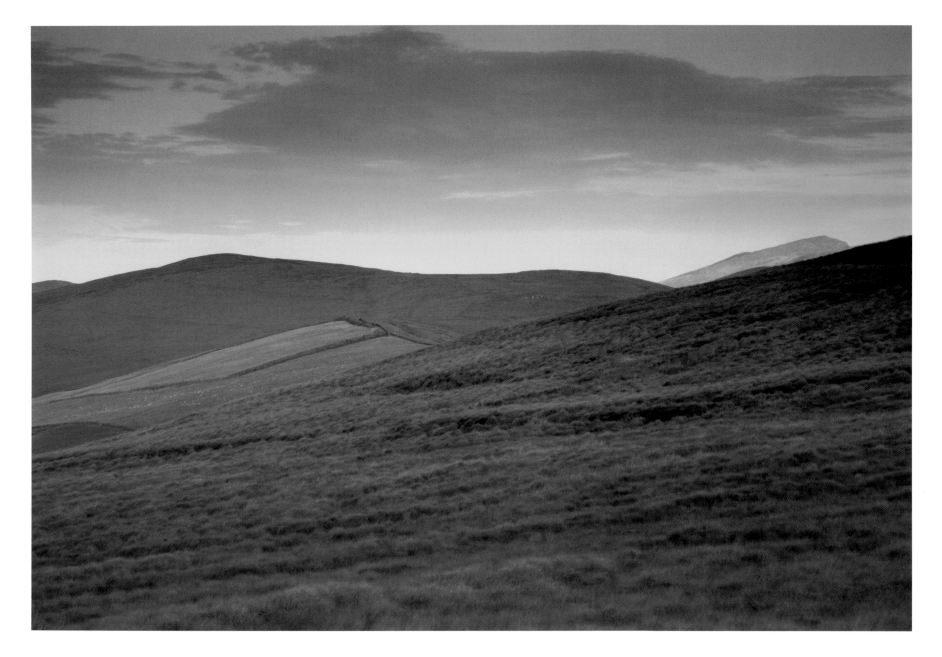

HILLS AT DAWN
Camp, Dingle Peninsula

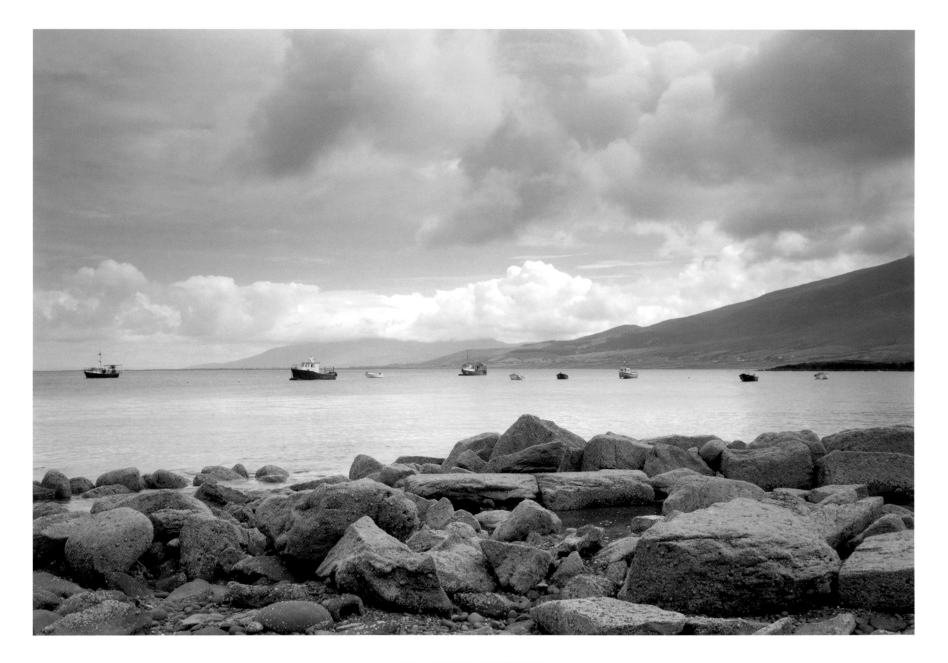

BRANDON HARBOUR
Brandon Bay, Dingle Peninsula

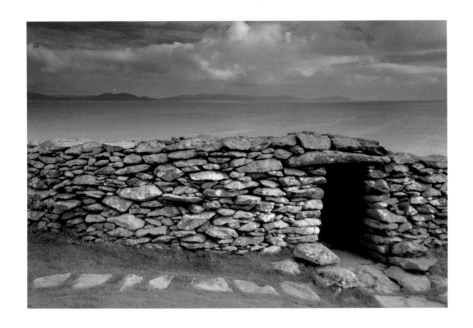

DUNBEG FORT
Slea Head, Dingle Peninsula

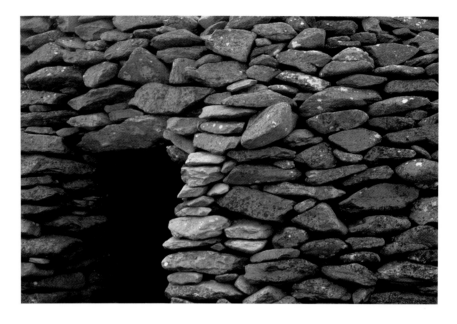

BEEHIVE HUT
Slea Head, Dingle Peninsula

Dunbeg Fort is only one of many archaeological monuments on the Dingle Peninsula with its 6,000 years of history and almost 2,000 documented historic sites.

Dunbeg Fort was begun around 800 BC and was used up to the tenth century AD. What the site was used for, however, is still lost in the mist of time. It may have been defensive or used for ritual purposes or it may simply have been the homestead of a local family. Standing inside these old walls overlooking Dingle Bay never fails to make my mind wander back in time and imagine what it was like to live in this remote spot thousands of years ago.

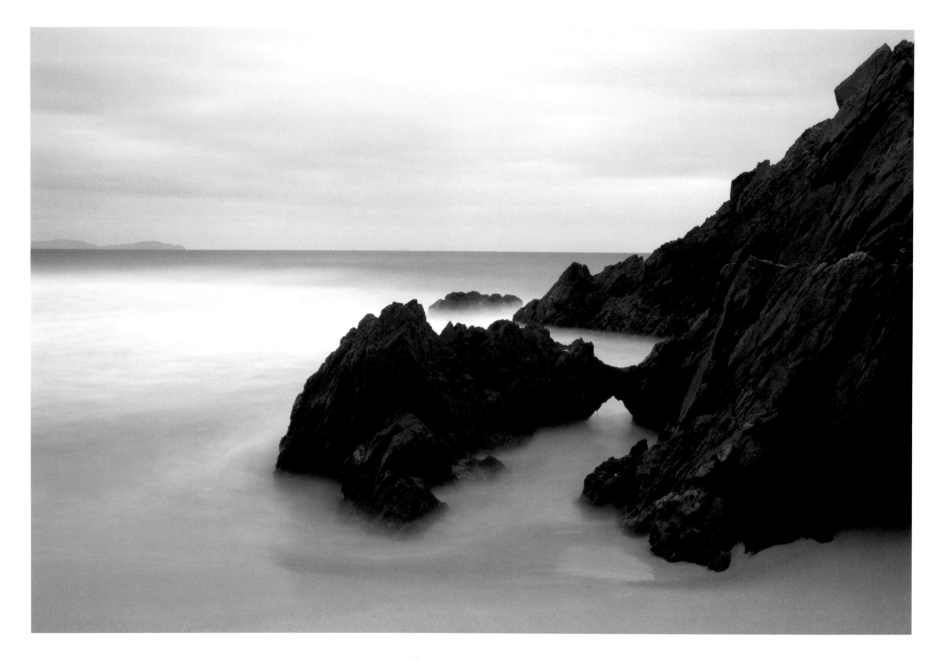

ROCK & OCEAN
Coumeenoole Bay, Dingle Peninsula

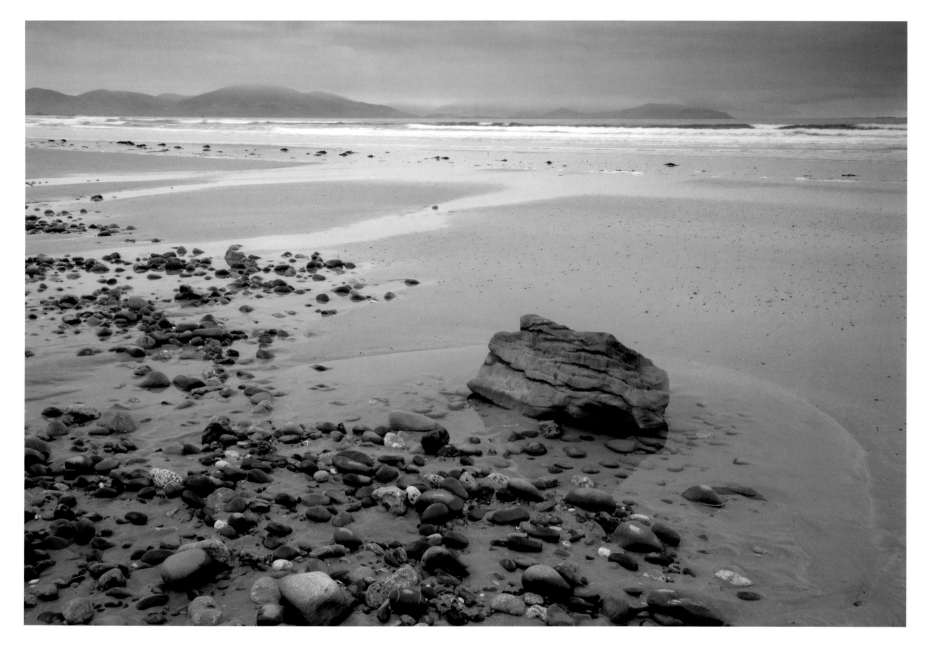

CLOUDS OVER DINGLE BAY
Banna Beach, North Kerry

WHERE THE RIVER MEETS THE SEA

WEST CLARE AND THE SHANNON ESTUARY

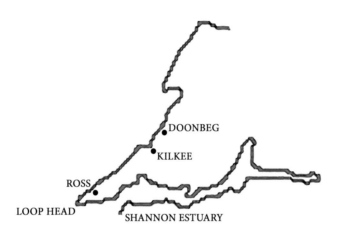

DOONBEG

KILKEE

ROSS

LOOP HEAD

SHANNON ESTUARY

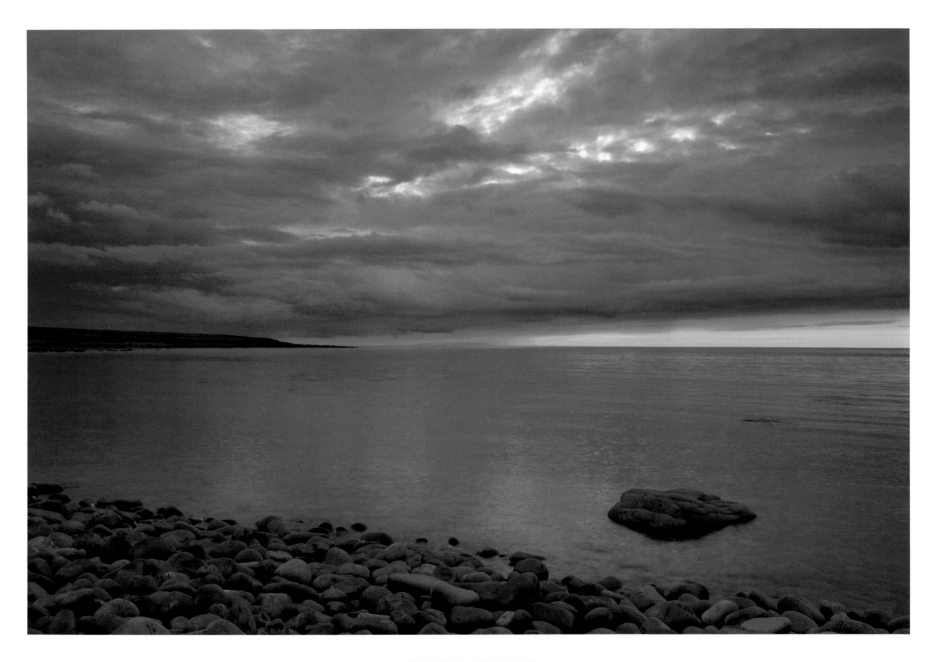

GLIMPSE OF LIGHT
Ross, Loop Head Peninsula

West Clare has been my home for some years now so it is no surprise this chapter has a special place in this book. Most of the places have been photographed over and over again, each time with a slightly different composition and in a different light, and each time I think I could have done better. It seems the closer I get to home the more critical I get of my own work.

The main part of west Clare is a narrow peninsula that stretches like a crooked finger out into the Atlantic Ocean.

The Loop Head Peninsula is bounded by the Shannon Estuary to the south, which features a collection of mudflats and sandy beaches. Loop Head on the very tip and the northern coast of the peninsula face the open Atlantic and are made of sheer cliffs, rock arches, sea-caves and offshore rocks. Further north where the peninsula joins the mainland, rocky shores, sandy beaches and dunes complete the west Clare seascape.

Away from the coast a flat, some might say featureless, landscape dominates. Blanket bog and more or less cultivated farmland are separated by hedgerows and overgrown walls and only a few trees defy the salt-laden Atlantic winds. It is a quiet and lonely place, a landscape characterised by high winds and heavy rain. The few calm days in spring and summer when there is no howling of the wind and the sea lies flat as a mirror seem almost unreal.

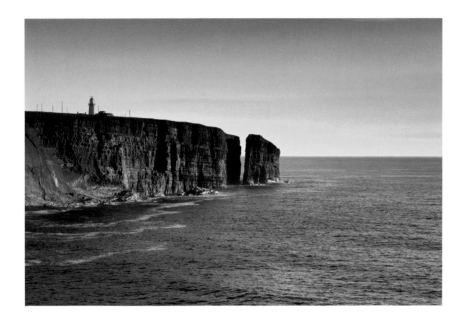

LOOP HEAD
Loop Head with Diarmuid & Grainne's Rock

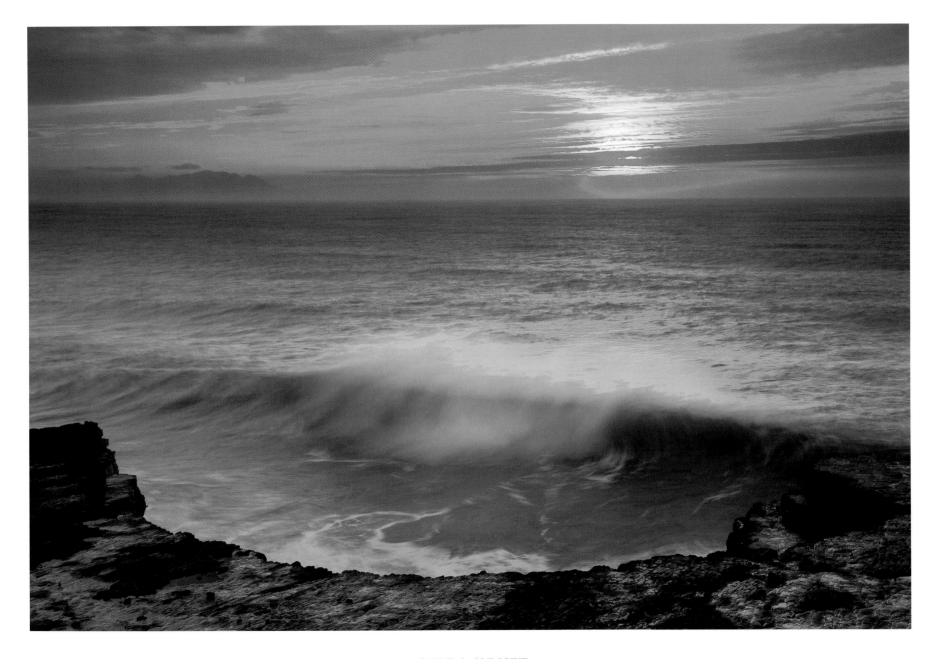

SURF & SUNSET
Loop Head, looking towards Kerry

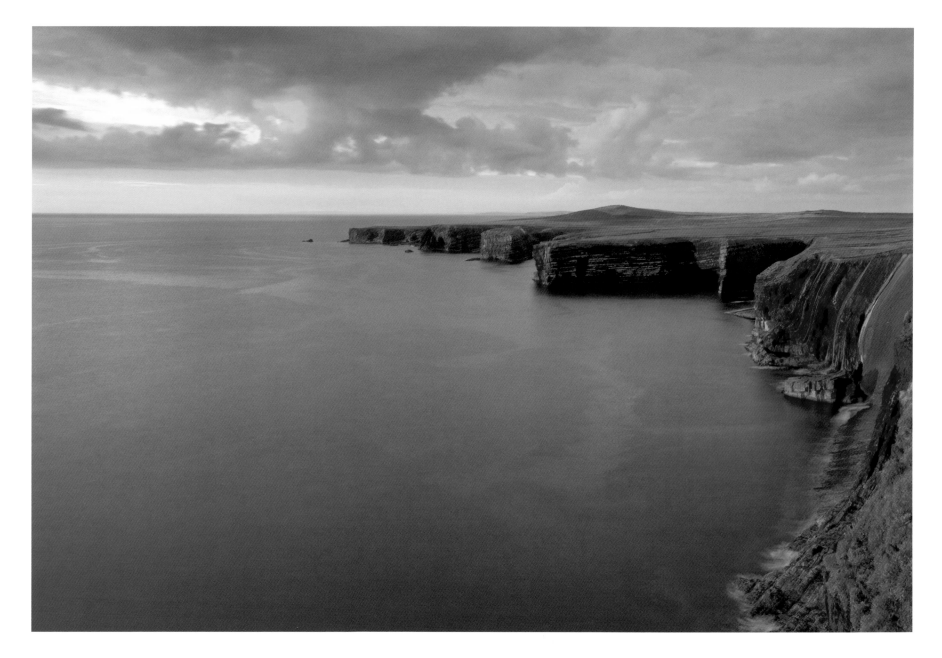

WEST CLARE COAST I
Loop Head, looking east

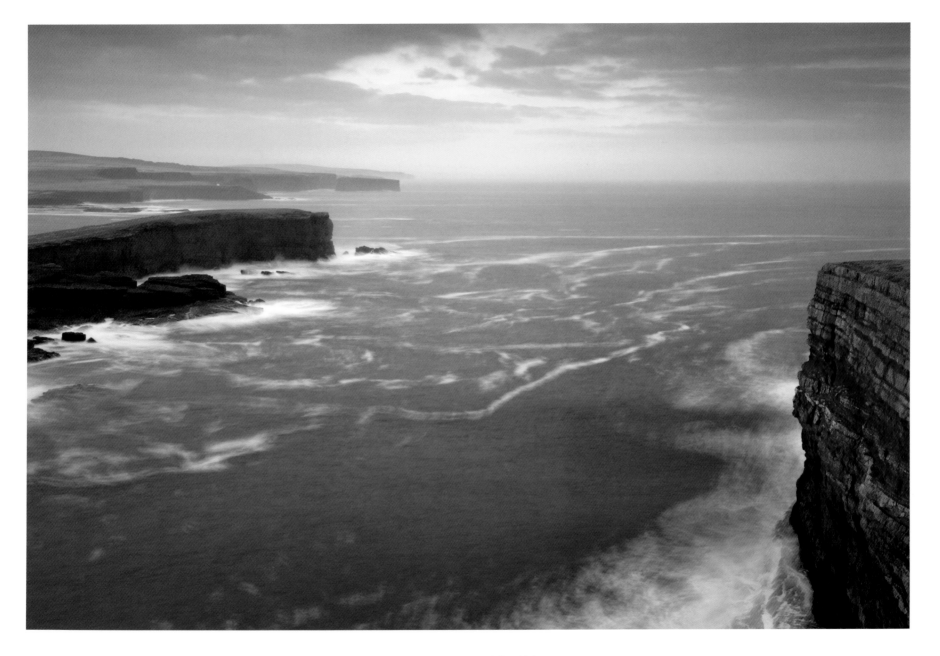

WEST CLARE COAST II
Moore Bay, looking west

FROST & FOOTPRINTS
Carrowmore, Doonbeg

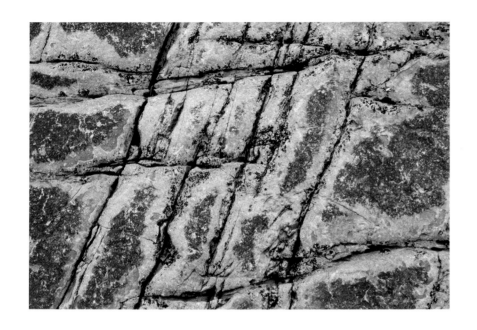

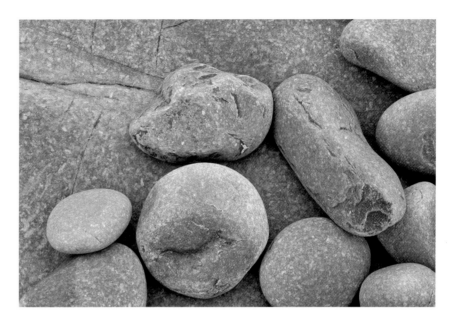

CARVED IN STONE
Ross, Loop Head Peninsula

PEBBLES
Ross, Loop Head Peninsula

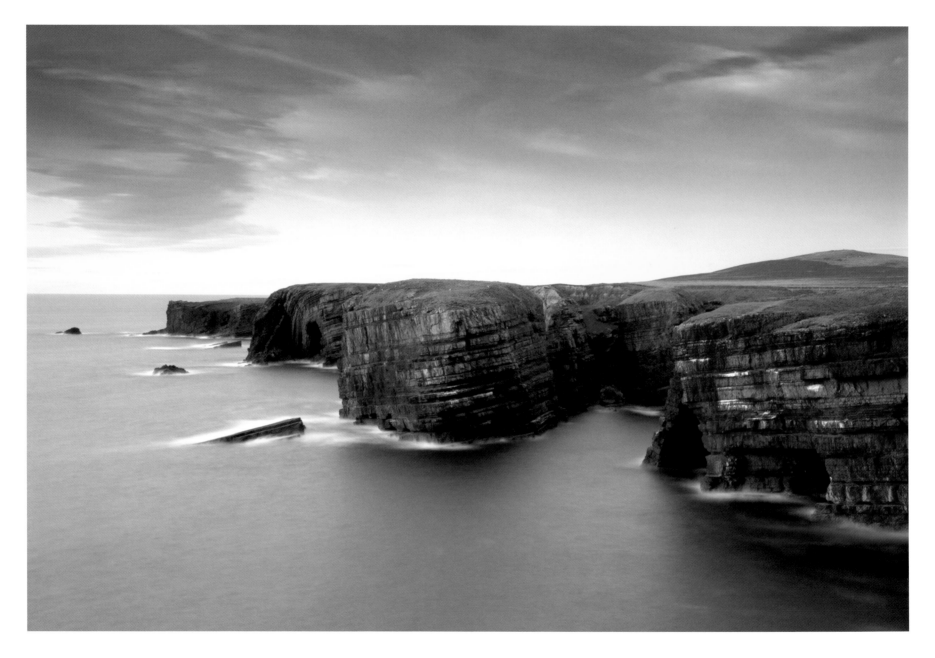

GULL ISLAND
Loop Head Peninsula

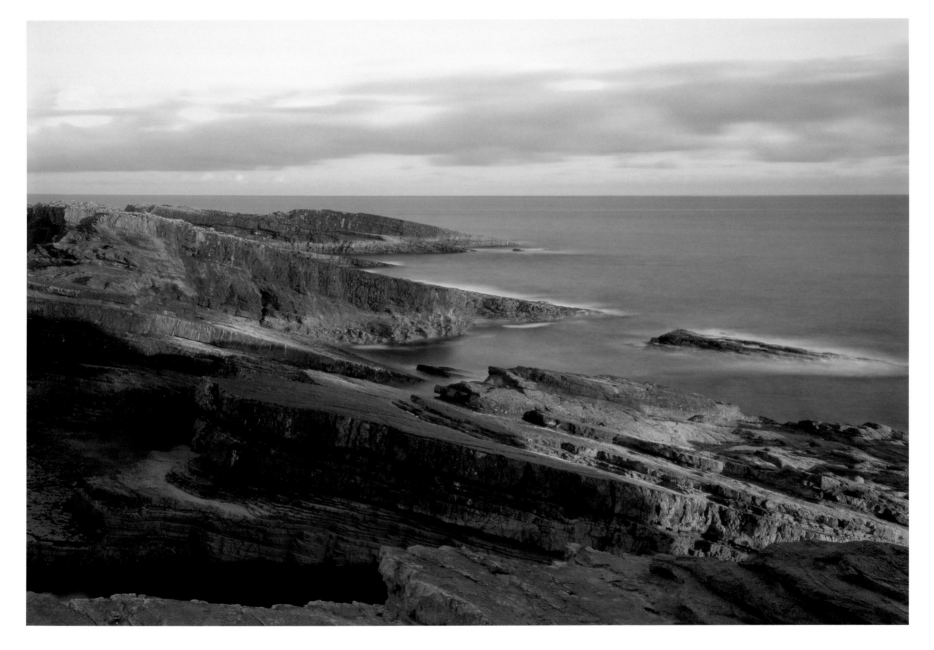

SUMMER MORNING
Ross, Loop Head Peninsula

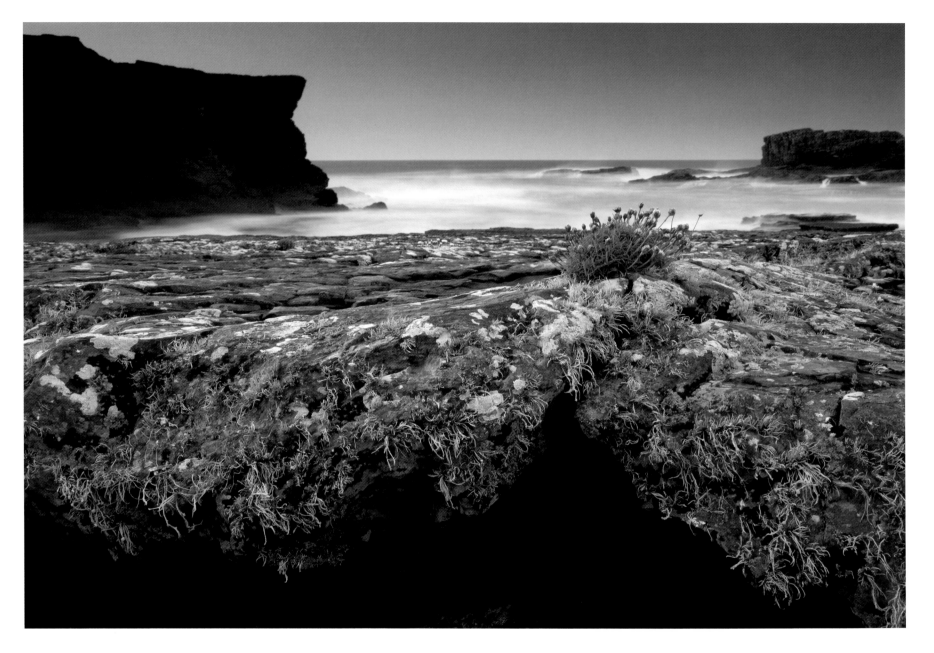

THRIFT ON LICHEN-COVERED ROCK
Ross, Loop Head Peninsula

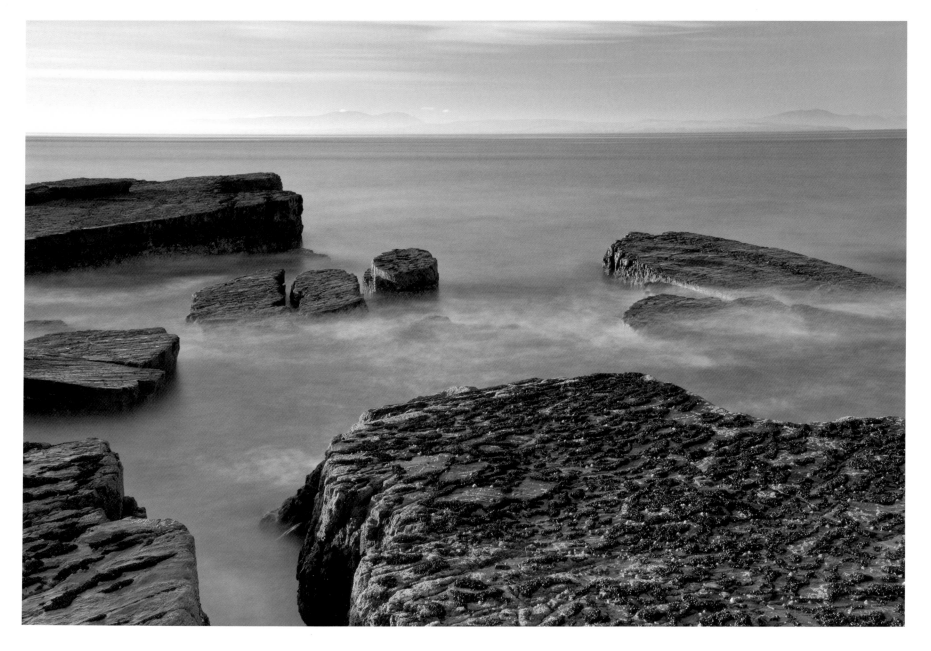

THE MOUTH OF THE SHANNON
Kilbaha Bay, Loop Head Peninsula

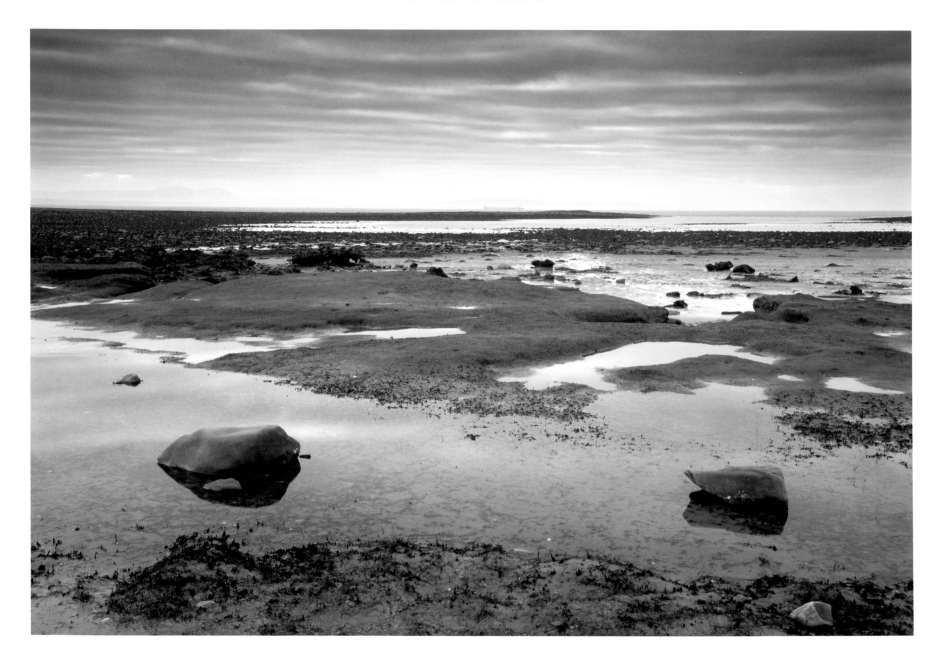

PEAT COAST
Rinevella Bay, Loop Head Peninsula

DROWNED FOREST
Rinevella Bay, Loop Head Peninsula

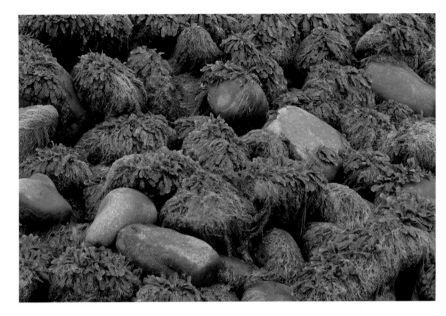

LOWER SHORE
Ross Bay, Loop Head Peninsula

Looking at Ireland today it is hard to imagine that extensive forests once covered the island. Some thousand years ago a radical climate change combined with human interference destroyed most of Ireland's forests and formed the raised and blanket bogs for which Ireland is famous today.

Rinevella Bay at the mouth of the Shannon is a reminder of this past. What looks at first sight like solid bedrock turns out to be soft and squelchy peat. The shoreline is covered with tree trunks of different shapes and sizes. Some have been washed free by the tides while others seem to be growing right out of the peat. Walking among these trees always sends me back to Ireland's past and sometimes I can almost hear the sounds of a long-vanished forest.

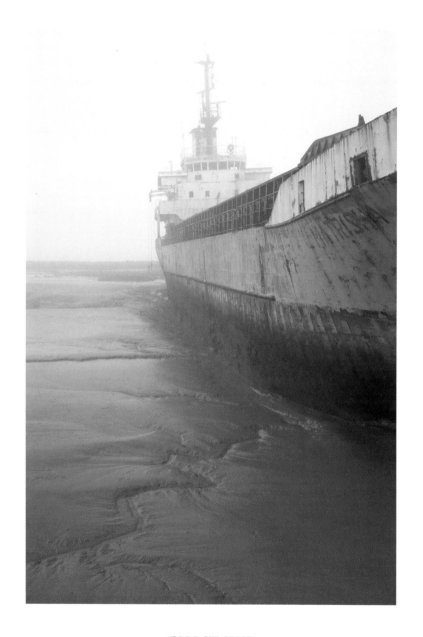

The Shannon Estuary stretches from the city of Limerick for 113 km to the mouth of the Shannon that opens between Loop Head in County Clare and Kerry Head. Apart from being one of Ireland's most important shipping routes the estuary is also one of Europe's most important conservation sites.

The extensive mudflats and sheltered bays provide ideal habitats for many species of birds, seals and otters and the waters of the estuary are home to Ireland's only resident group of bottlenose dolphins.

Surprisingly the heavy shipping traffic – commercial and leisure alike – and the two power stations – each guarding one side of the estuary – all coexist peacefully with the rich wildlife. For me the Shannon Estuary is an encouraging example that our modern way of life does not necessarily mean that nature has to give way.

GHOST SHIP
Inishmurry Quay

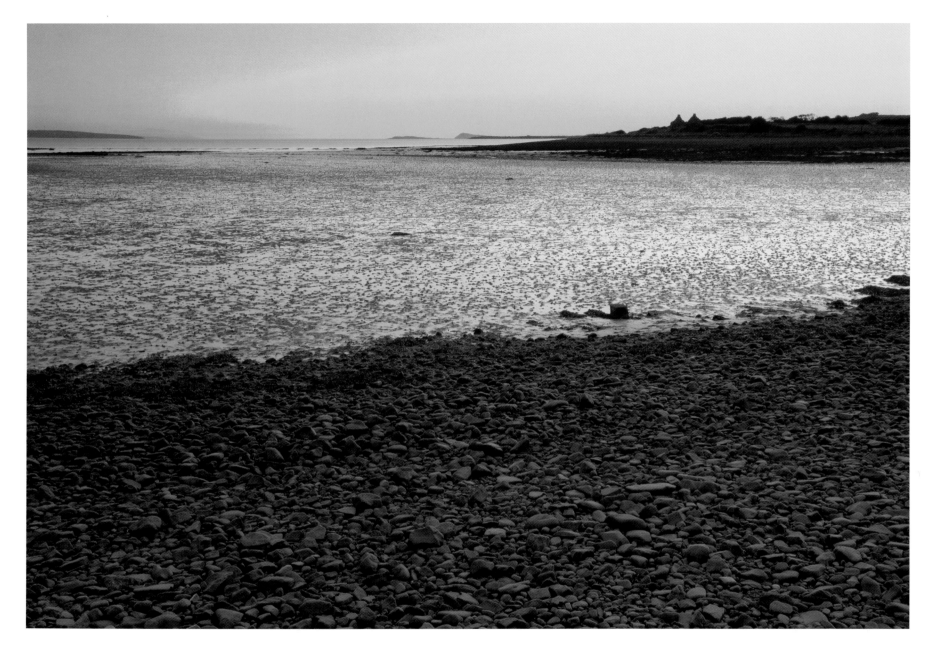

ESTUARY SUNSET
Poulnasherry Bay

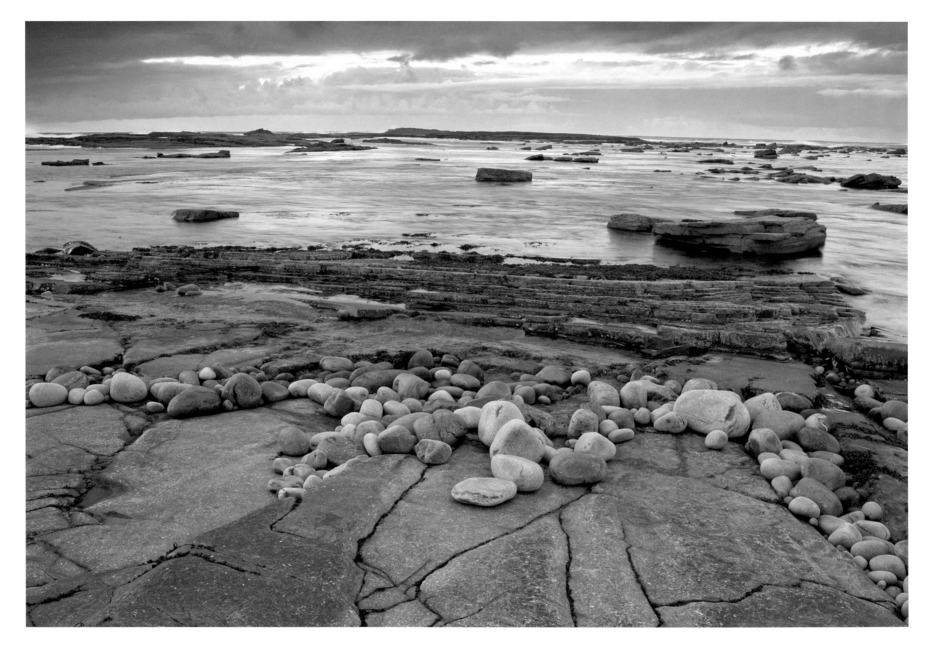

POLLOCK HOLES
West End, Kilkee

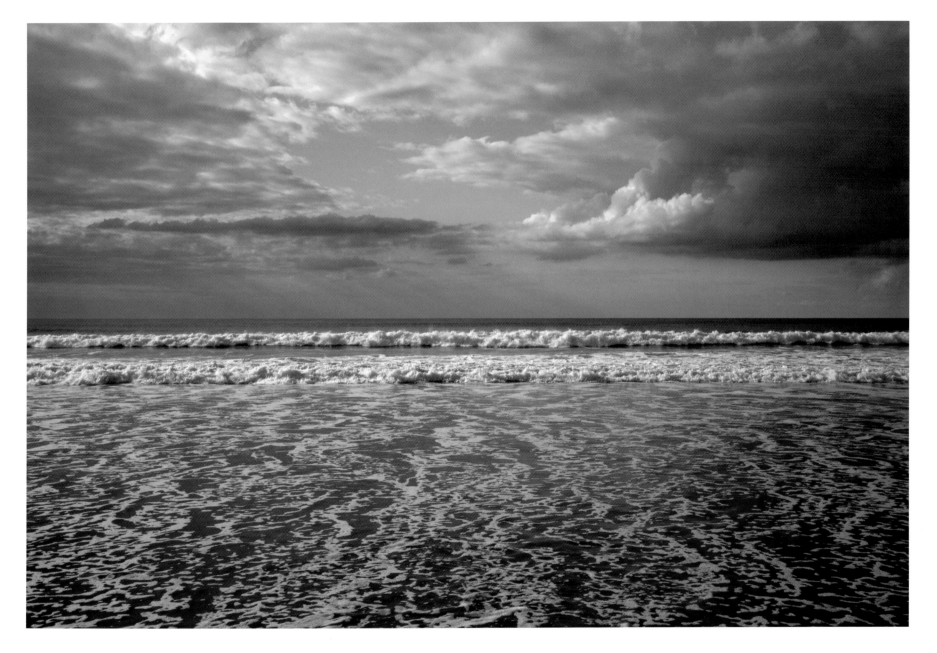

INCOMING TIDE
White Strand, Doonbeg

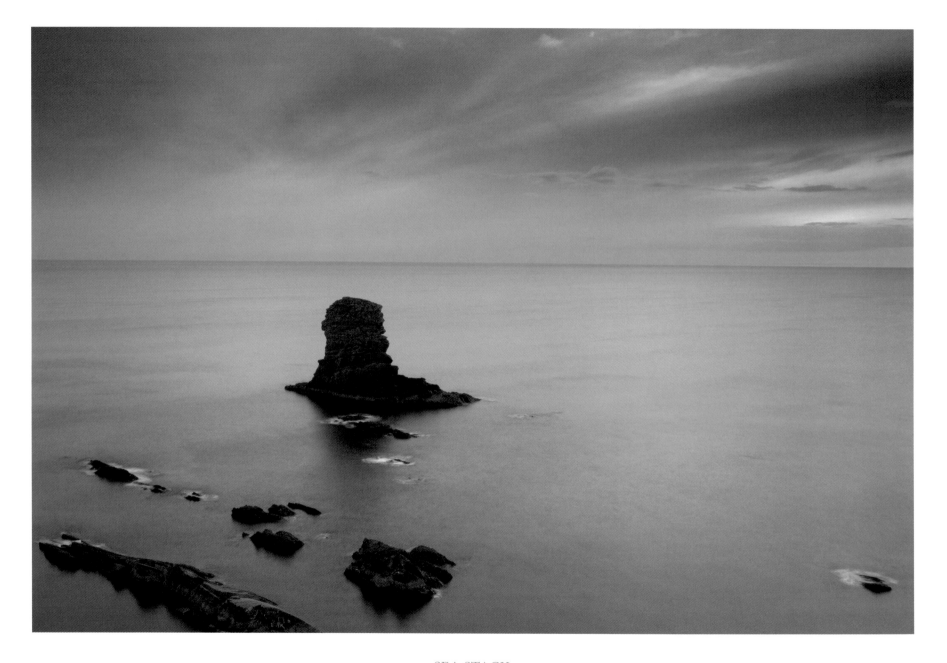

SEA STACK
Moveen, Loop Head Peninsula

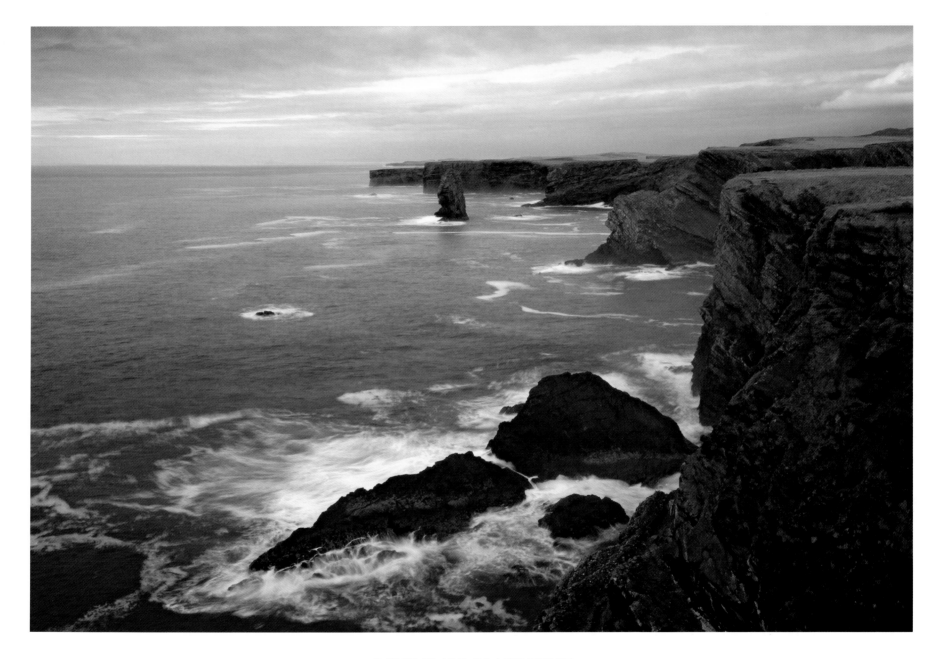

WEST CLARE COASTLINE III
Moveen, Loop Head Peninsula

LIMESTONE COUNTRY

THE BURREN

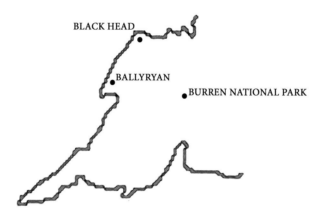

BLACK HEAD

BALLYRYAN

BURREN NATIONAL PARK

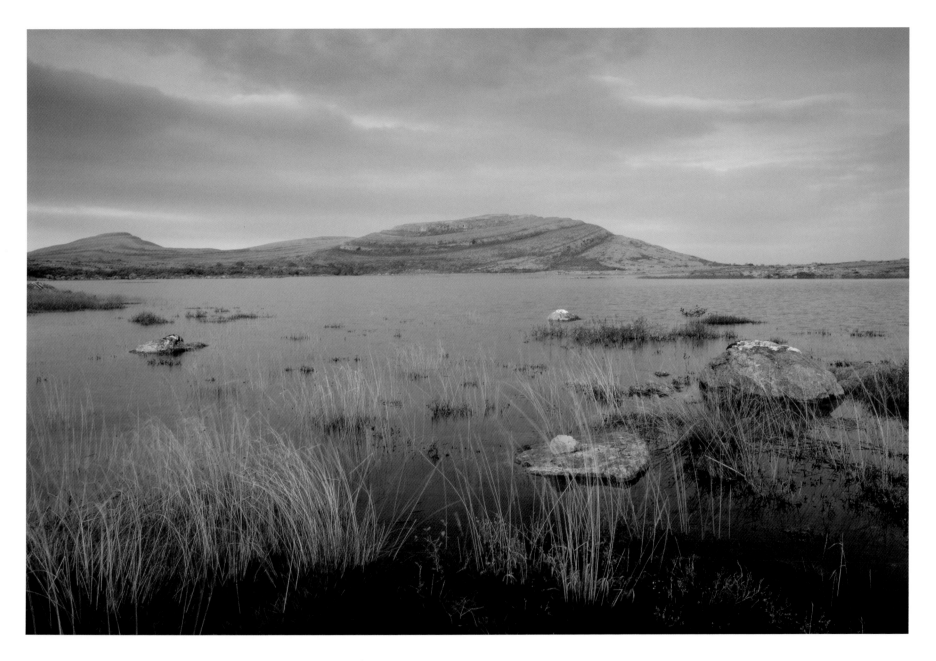

MULLAGHMORE
Burren National Park

It is no secret that the Burren is very dear to me. Many landscape photographers have one place they care for most, one place that challenges and boosts their creativity, one place they have devoted their work to. Ansel Adams' work in Yosemite is legendary. Peter Dombrovskis is renowned for his work in Tasmania. Jim Brandenburg has put his heart and soul into photographing the boreal forests and the prairie of Minnesota. I would not dare to compare myself with these masters of photography but the one and only place for me is the Burren. If my work does its part in protecting and conserving this unique place for future generations I will be more than happy.

This is a landscape you would not expect in Ireland. The Burren is a grey ocean of limestone shaped into terraced hills, smooth pavements dotted with erratics and fields of razor-sharp rocks. The geological term for this landscape is limestone karst, named after an area in Slovenia where this type of landscape was first described.

Limestone is a sedimentary rock derived from marine shells and corals, and is soluble to water. The limestone of the Burren originated in a warm tropical sea near the equator millions of years ago. Eventually this limestone was moved to its current position on the globe and raised above sea level.

Over millennia rain, wind and radical climate changes gave the Burren its current form. Typical of limestone areas, the Burren also extends underground where rainwater and rivers have formed seemingly endless cave passages of which only a tiny portion have yet been explored.

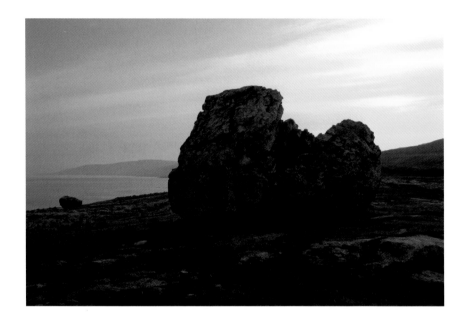

BROKEN ERRATIC
Ballyreen

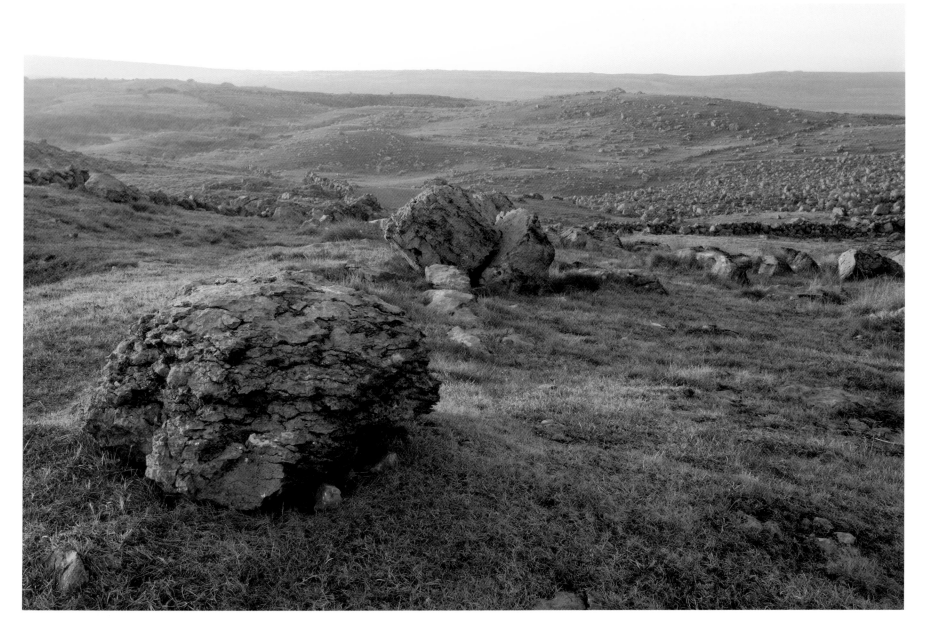

WINTER MORNING
Ballyryan

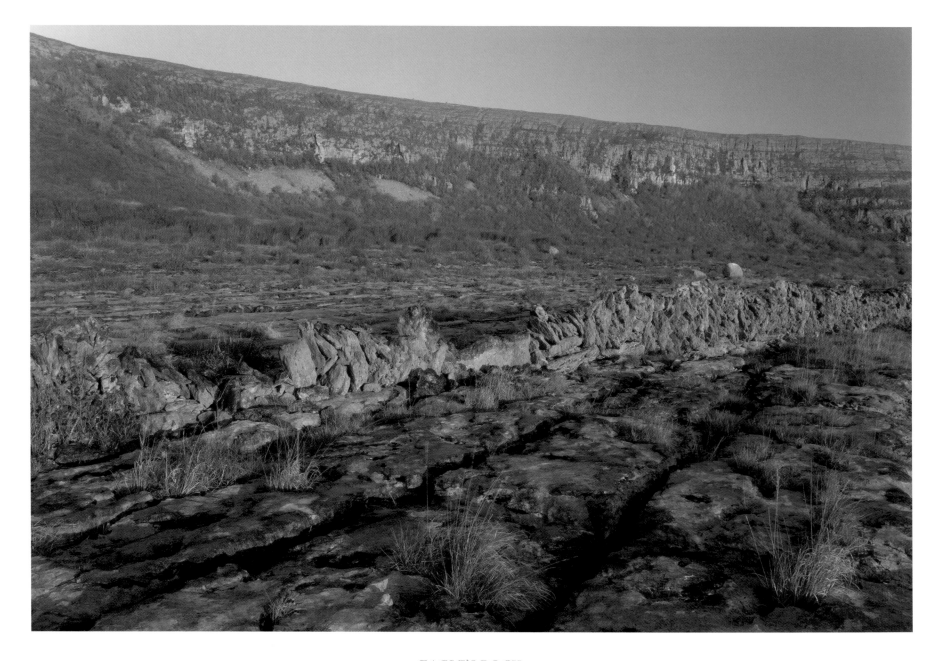

EAGLE'S ROCK
Keelhilla Nature Reserve

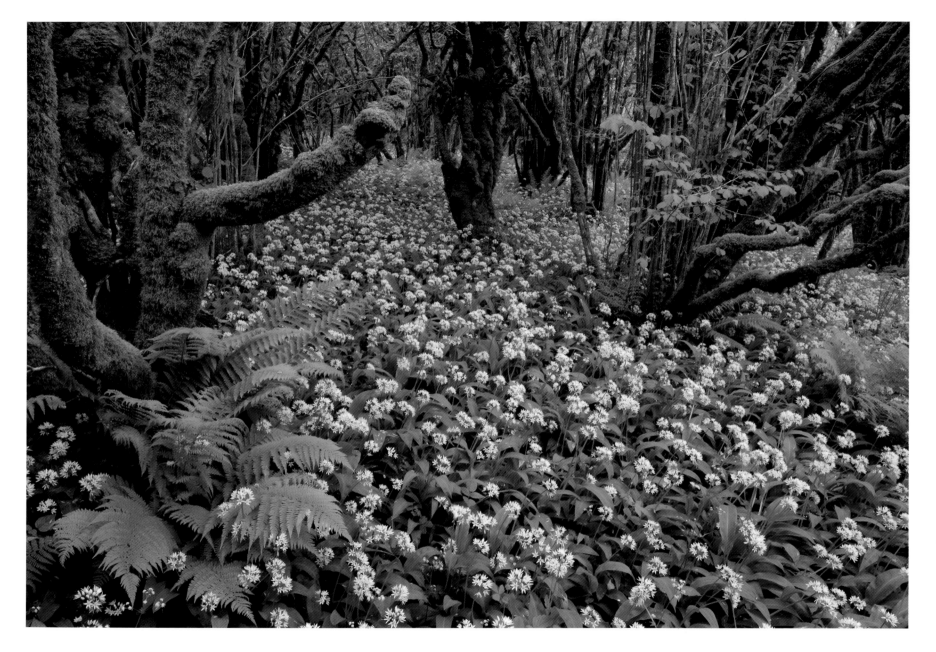

WILD GARLIC & HAZEL WOOD
Keelhilla Nature Reserve

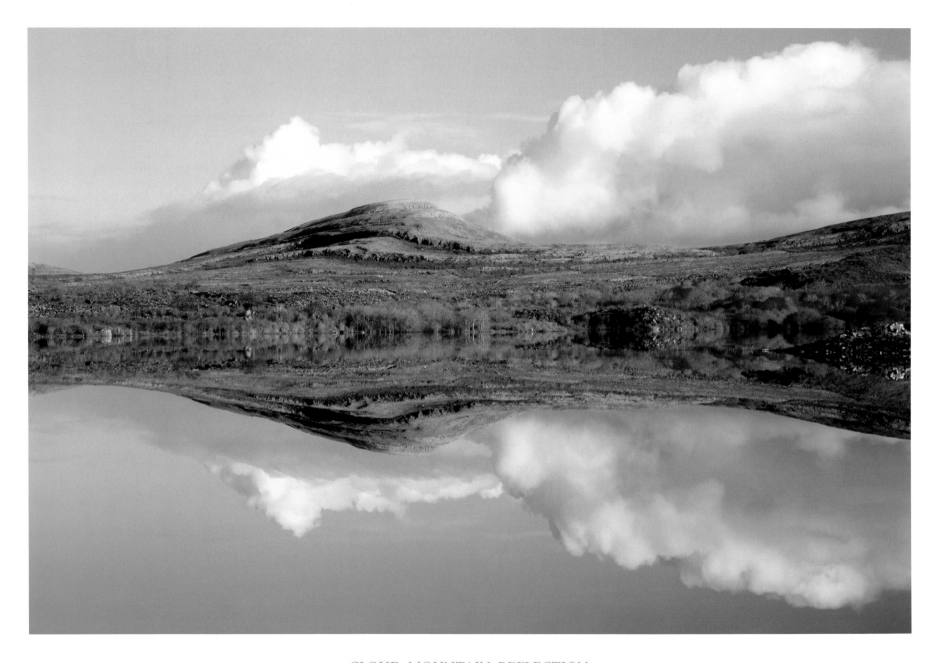

CLOUD, MOUNTAIN, REFLECTION
Knockanes Mountain & Loch Gealain, Burren National Park

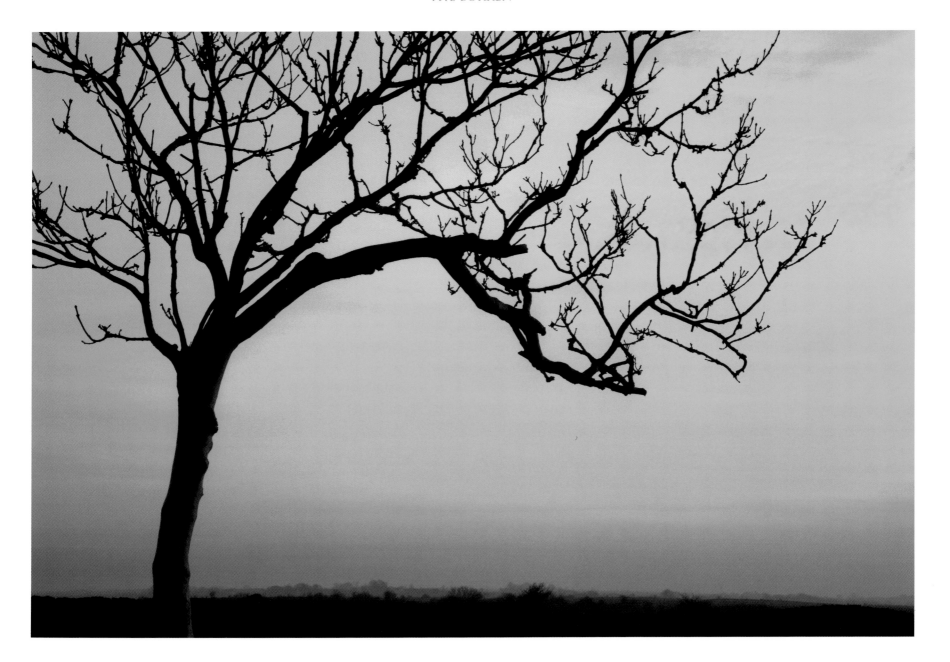

LONE TREE
Ballaghaglash

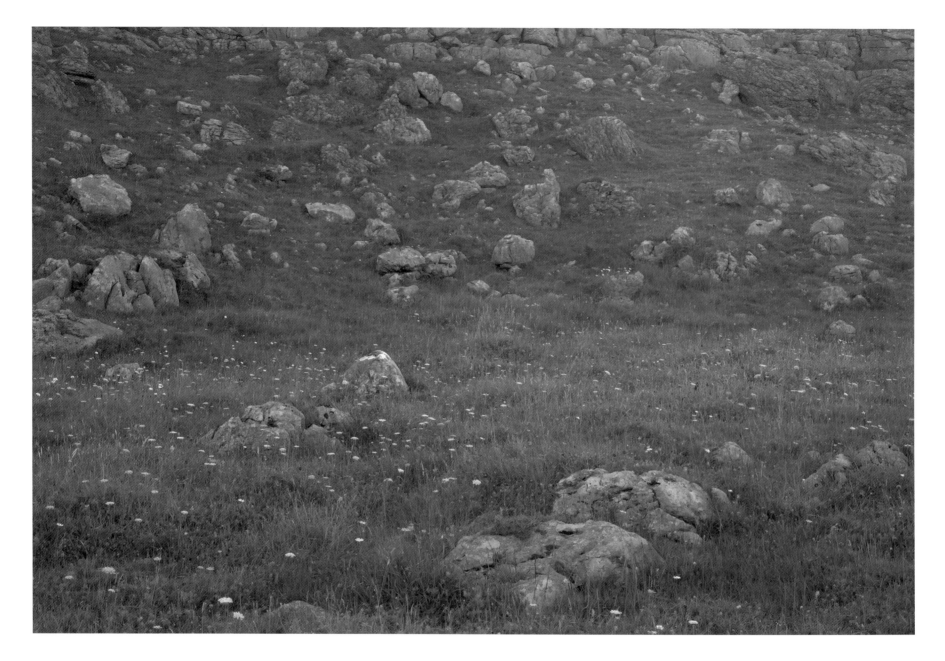

BURREN MEADOW
Ballyryan

GRASSES & STONES
Burren National Park

SLOES
Ballaghaglash

The Burren is renowned for its unique flora. Most of the plants growing in the Burren are by no means rare and can be found more or less all over Europe. What makes the Burren special are its plant communities. Arctic plants grow side by side with subtropical species, alpine plants thrive by the coast and woodland flowers can be found on open limestone country. There is no other place in the world where you will find spring gentians growing within a stone's throw of the Atlantic Ocean or mountain avens mingling with Mediterranean orchids.

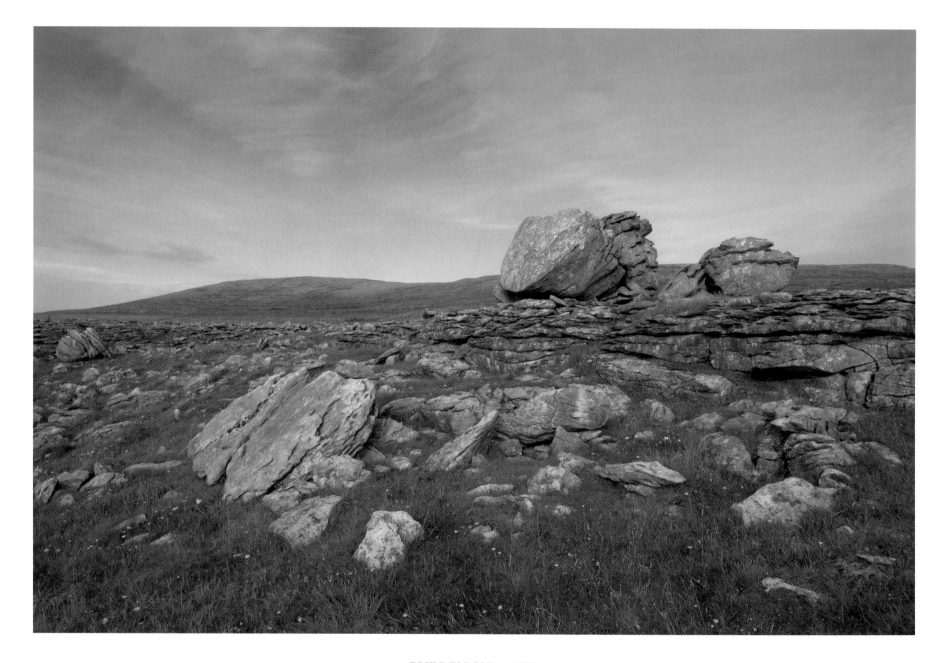

BURREN SUMMER
Black Head

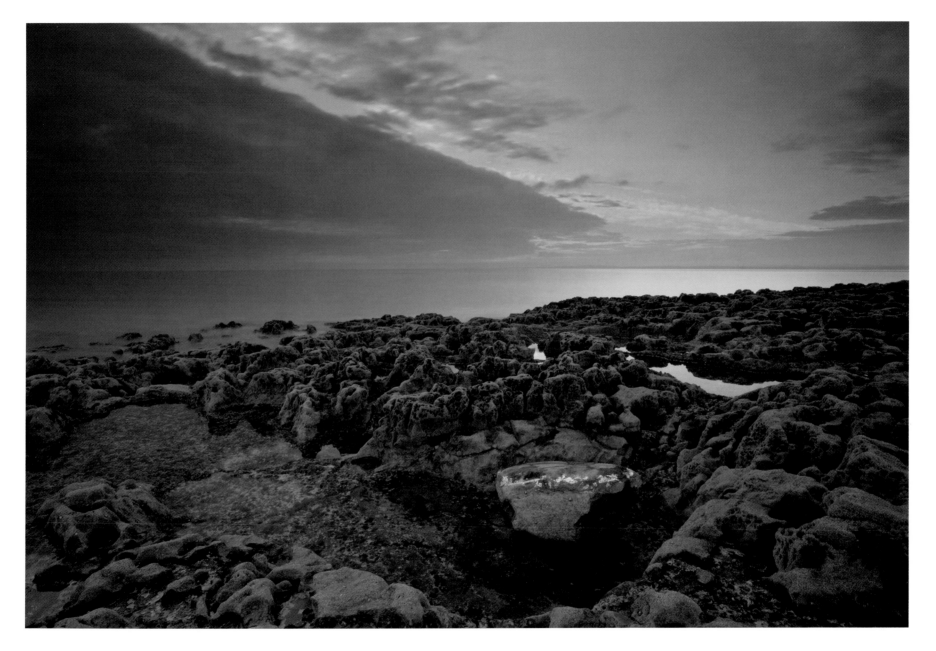

LIMESTONE COAST
Black Head

LIMESTONE PAVEMENT & ERRATIC
Black Head

GRIKES
Black Head

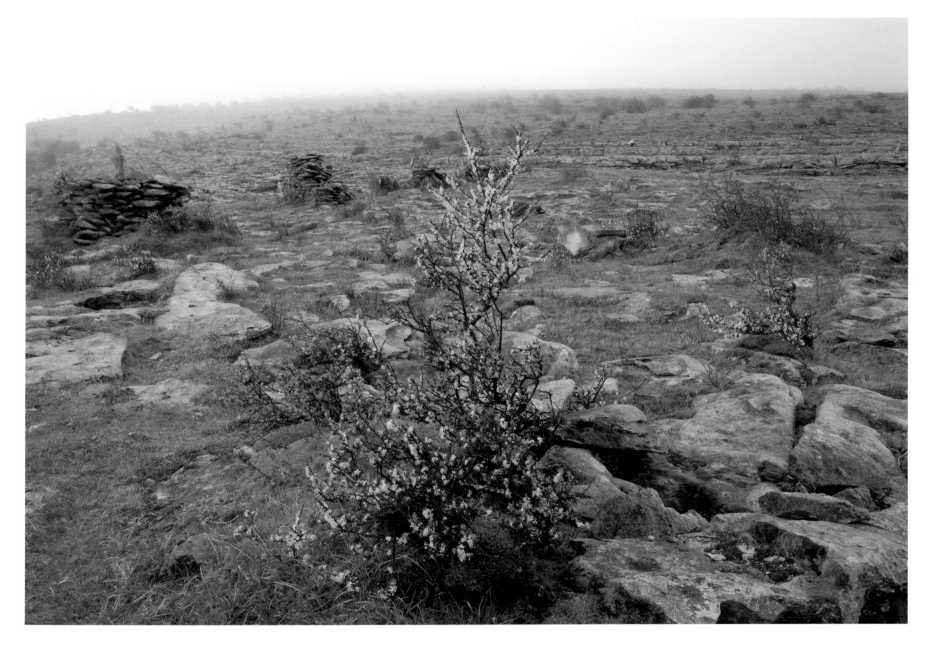

FOG & BLACKTHORN
Fahee South

Turloughs are a unique feature of the Burren. These seasonal lakes are connected to the water table and rise and fall with the seasons. Some of these 'dry lakes' disappear completely during the drier summer months, others like Lough Bunny are not turloughs in the real sense but nevertheless experience a huge fluctuation in water levels during the seasons.

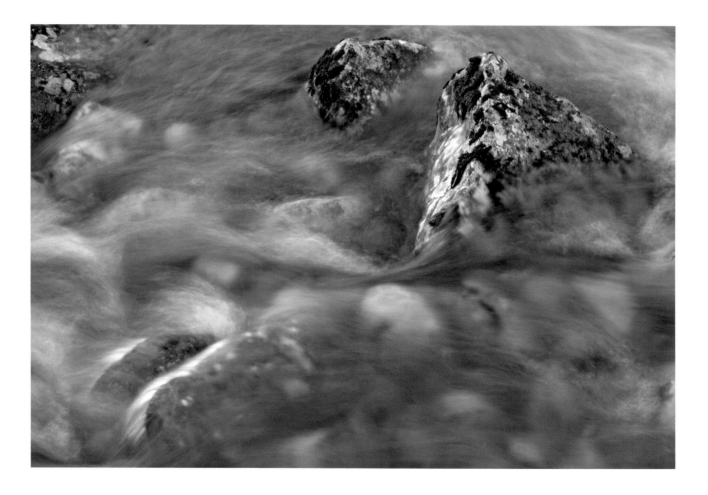

CAHER RIVER
The Khyber Pass

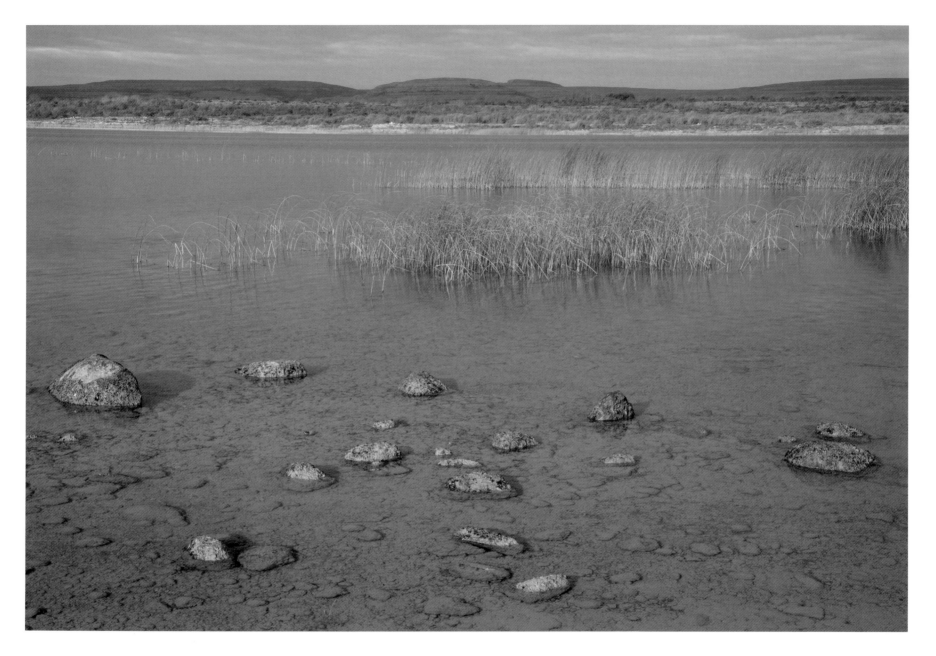

BURREN SKYLINE
Lough Bunny

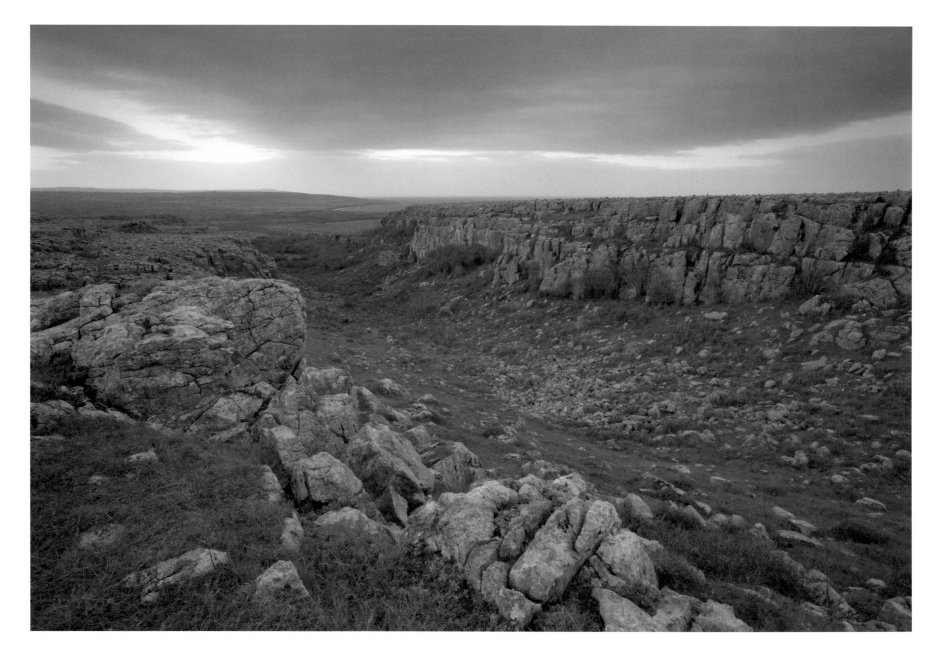

WINTER VALLEY
Ballyryan

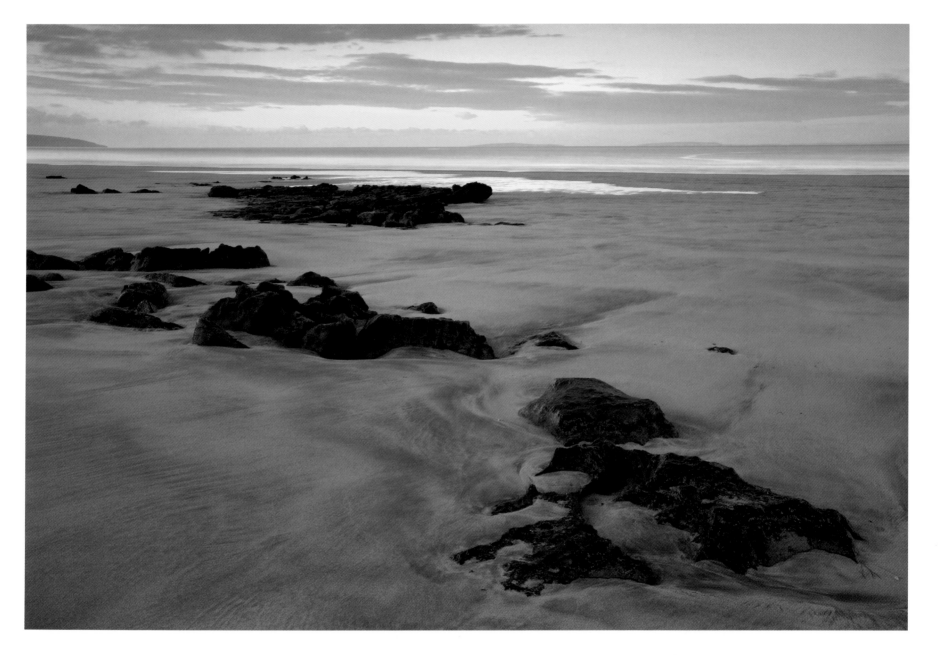

FANORE BEACH
Fanore

THE HEART OF THE WEST

CONNEMARA AND COUNTY GALWAY

KILLARY HARBOUR

INAGH VALLEY

BALLYCONNEELY

TWELVE BENS

ROUNDSTONE

LOUGH CORRIB

COOLE PARK

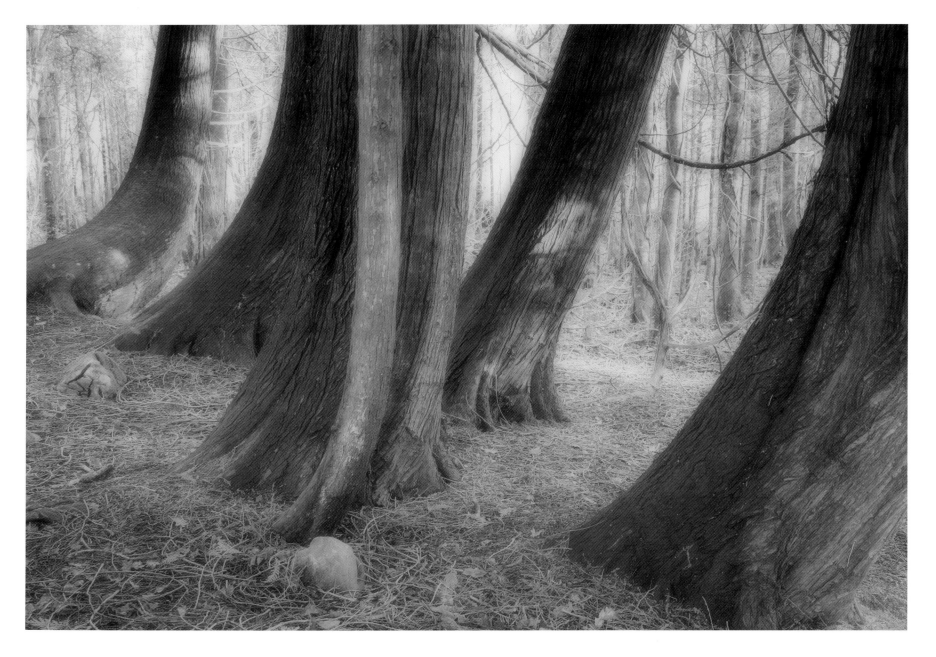

CLEARING
Coole Park, County Galway

County Galway is the second biggest county in Ireland and stretches from the Atlantic Ocean all the way to the River Shannon in the midlands. Lough Corrib, the biggest lake in the Republic of Ireland, almost cuts the county in half and divides the flat and fertile east from the wild, romantic west.

Connemara covers the biggest part of the western region of County Galway and occupies an area of about 2,000 square km. A possible origin of the name is Conmaicne Mara, the branch of the ancient Conmaicne tribe that 'lived by the sea'.

The heart of Connemara is formed by two mountain ranges, the Twelve Bens and the Maumturk Mountains, which are separated by the wide Inagh Valley. Around these mountains stretch miles and miles of blanket bog with countless lakes, pools, streams and rivers. An incredibly ragged coastline unites the Connemara landscape.

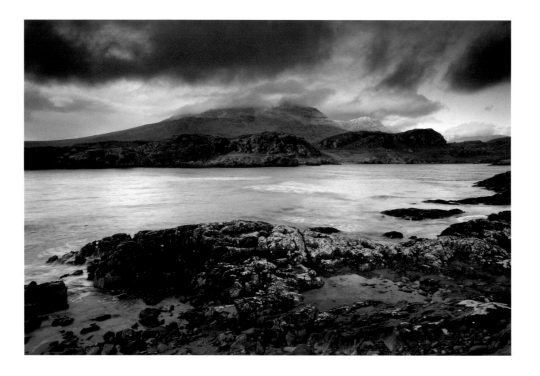

WEATHER OVER MWEELREA MOUNTAINS
from Carrickglass, Connemara

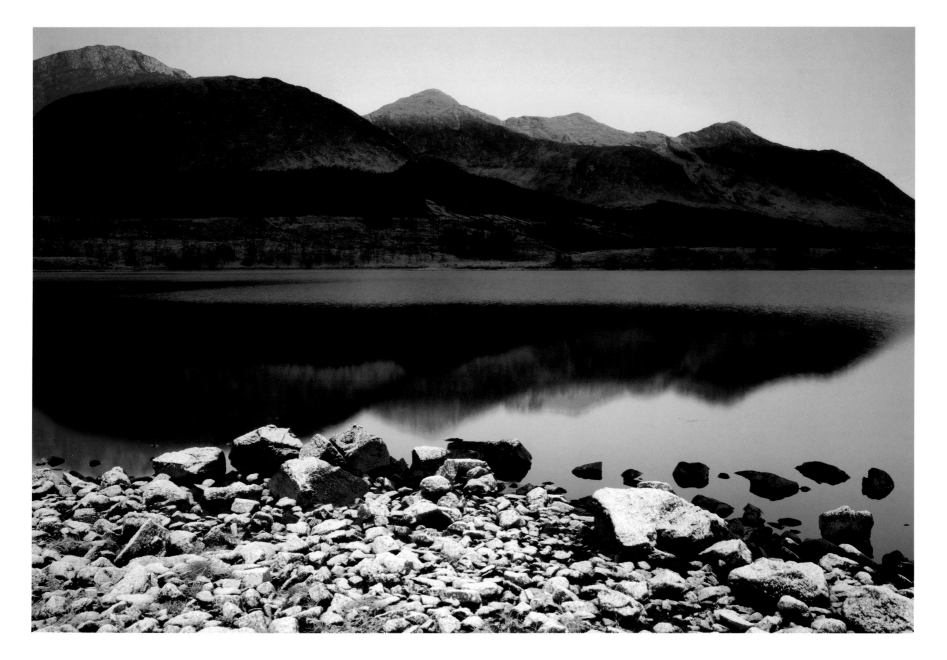

WINTER SUNRISE
Lough Inagh & Twelve Bens, Inagh Valley, Connemara

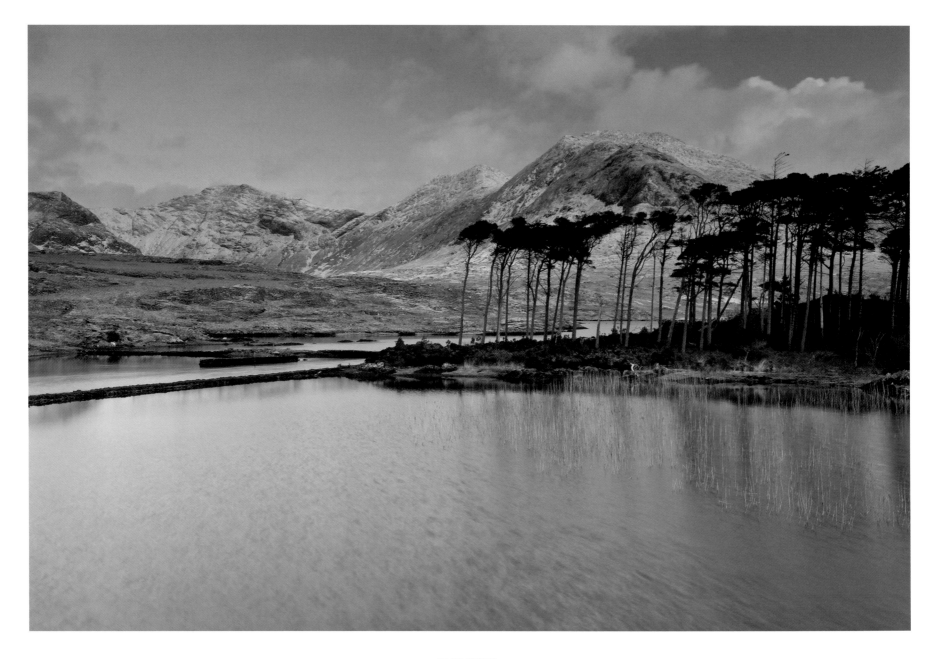

WINTER
Derryclare Lough, Connemara

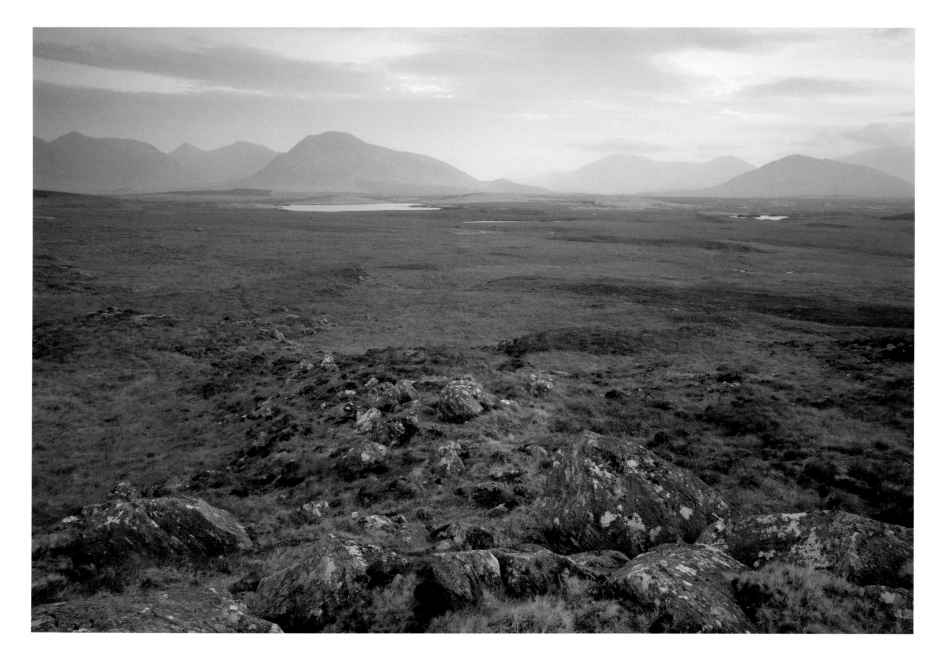

CONNEMARA MOUNTAINS
Twelve Bens & Maumturk Mountains from Lettershinna, Connemara

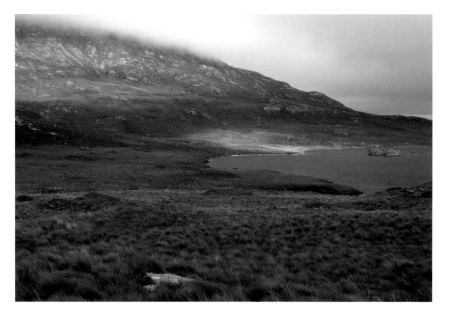

LOW CLOUD
Maumwee Lough & Lackavrea Mountain, Connemara

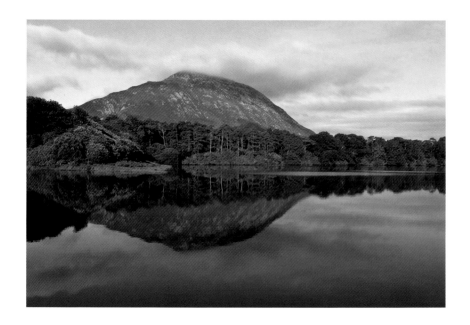

DIAMOND HILL
Pollacappul Lough, Connemara

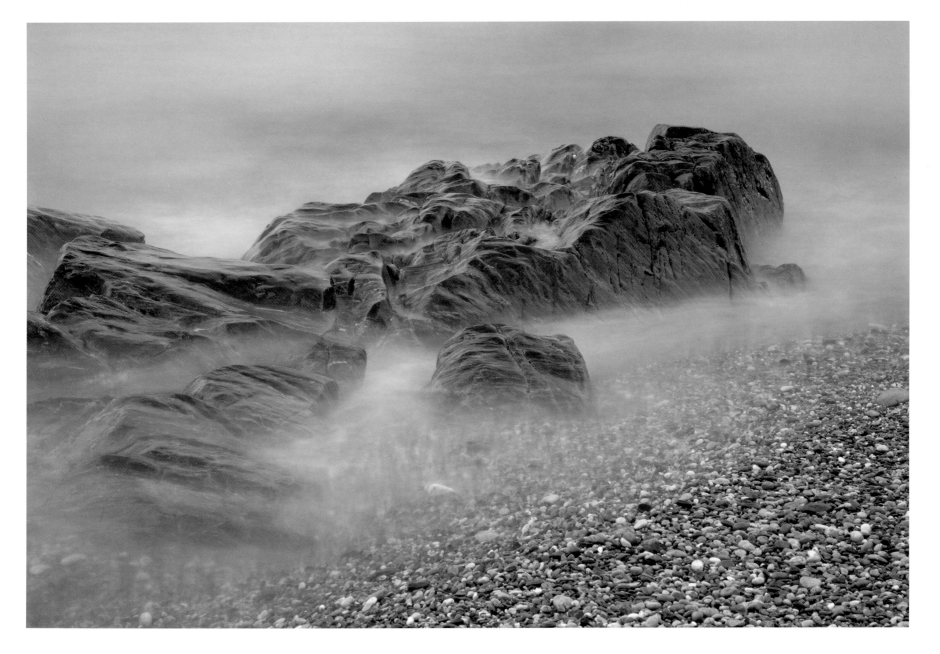

ROCK & SEA MIST
Eyrephort, Connemara

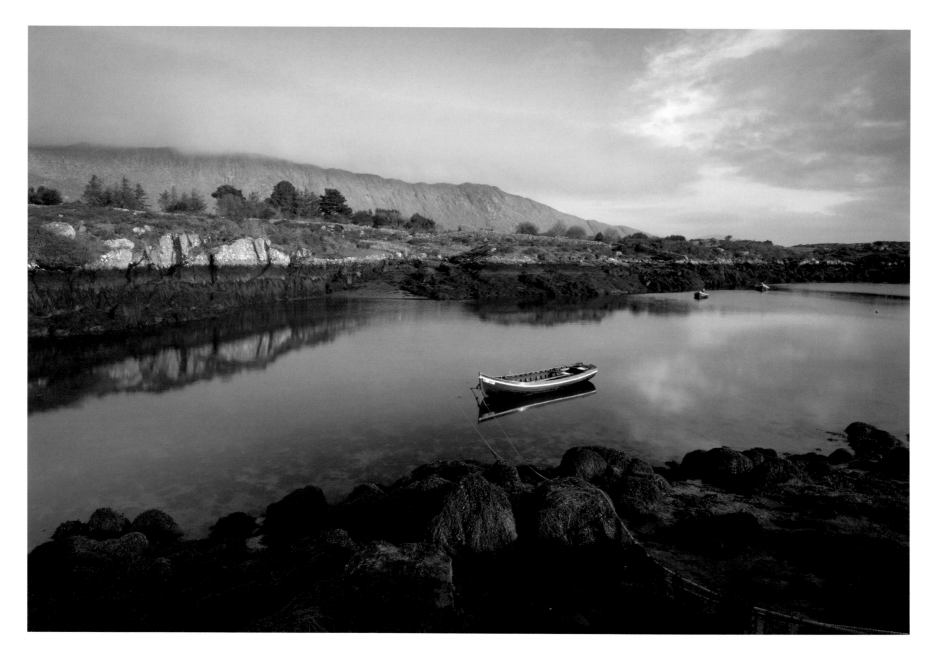

FLANNERY BRIDGE
Connemara

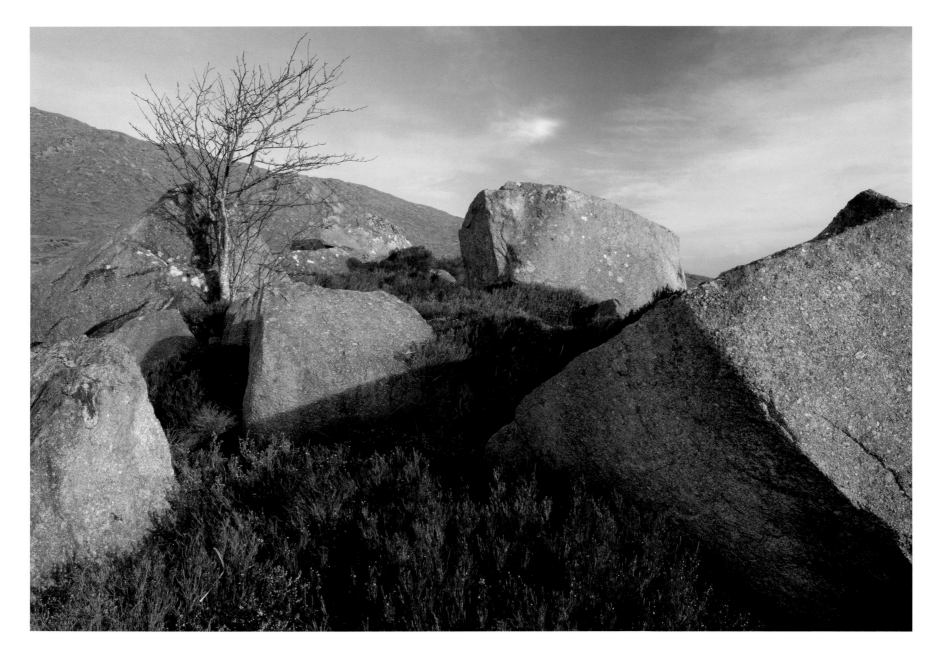

ERRATICS & TREE
Cnoc Mordain, Connemara

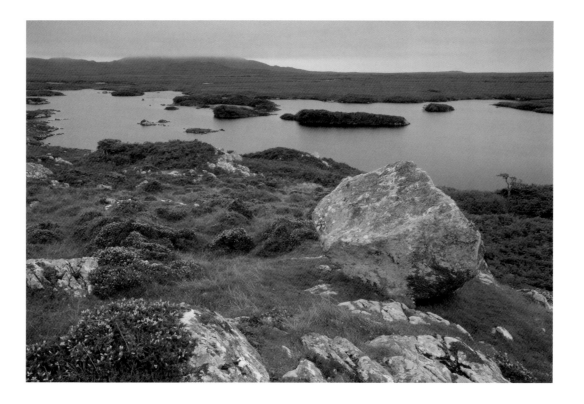

ROUNDSTONE BOG & ERRISBEG
Connemara

From Errisbeg mountain near Roundstone stretches a vast carpet of squelchy peat northwards. The Roundstone bog complex is one of the few intact examples of Atlantic blanket bog with a unique flora that makes it a place of international importance.

From a distance a bog surface looks rather uninteresting and uniform. A closer look however shows a pattern of flushes and fens, pools and streams, hollows, hummocks and rocky outcrops. Entering the world of the bog is a unique experience. The spongy ground forces you to slow down and adjust your speed to the pace of the bog. The outside world eases away and leaves you alone with heather, moss and lichen. The tranquility of the bog takes you in and each step reveals new colours and forms.

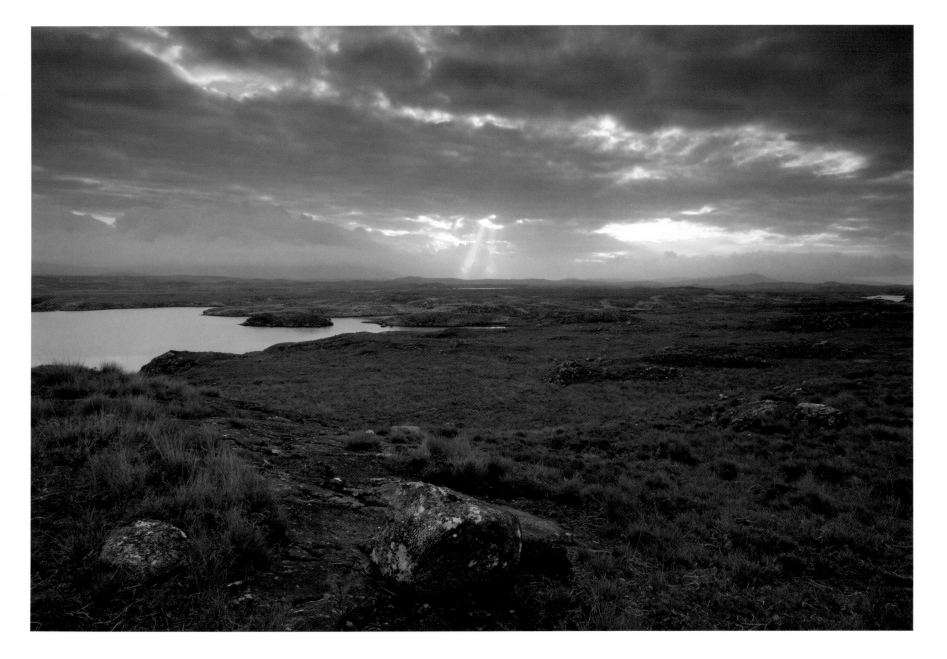

BOGLAND
Roundstone bog complex, Connemara

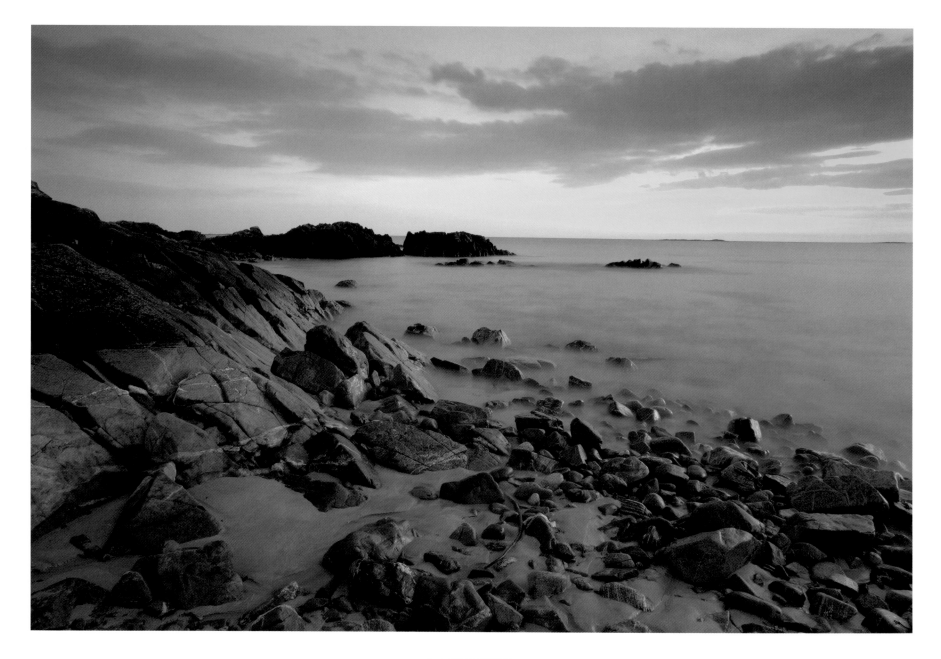

LAST LIGHT
Ballyconneely, Connemara

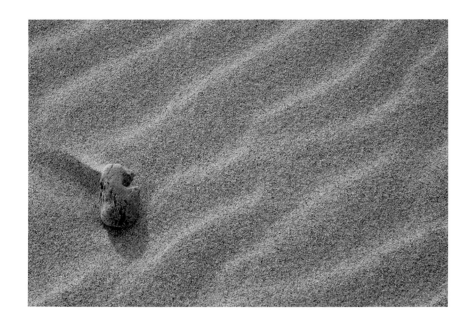

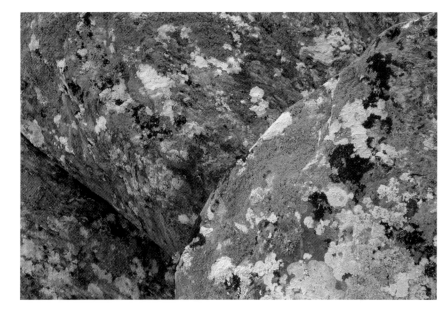

SAND & STONE
Ballyconneely, Connemara

LICHEN ON ROCK
Eyrephort, Connemara

The coastline of Connemara is unlike any other in Ireland. This shoreline twists and turns for more than 400 km forming long inlets, sheltered bays, peninsulas and islands. Small harbours are scattered all along the coast. There are rocky shores and shores littered with pebbles or boulders. Soft and muddy shores are as abundant as sandy beaches. Adjacent to these sandy beaches machair can often be found, a grassland rich in flowers and unique to the west of Ireland and Scotland. Another specialty of the Connemara coast are the so-called 'coral strands'. Their texture looks and feels like they are made of fragments of coral. However, these broken and often branched fragments are of the skeletons of seaweed.

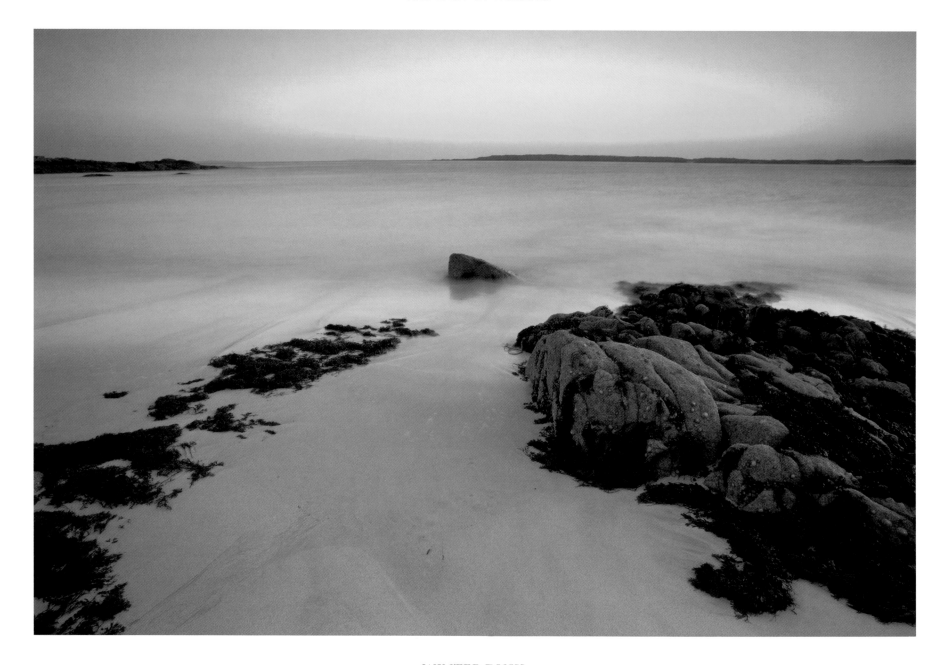

WINTER DUSK
Gorteen Bay, Connemara

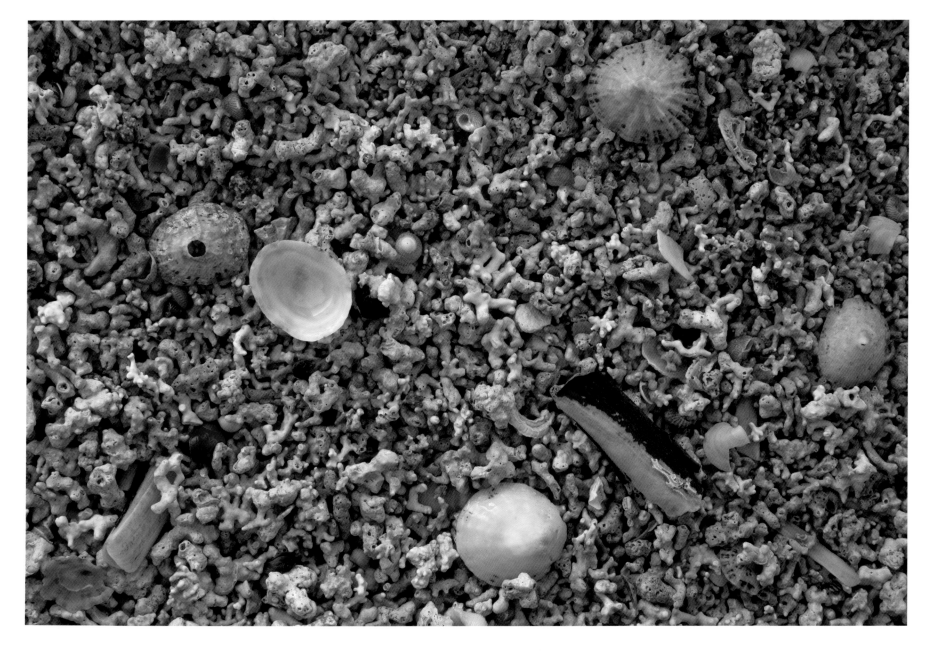

CORAL STRAND DETAIL
Greatman's Bay, Connemara

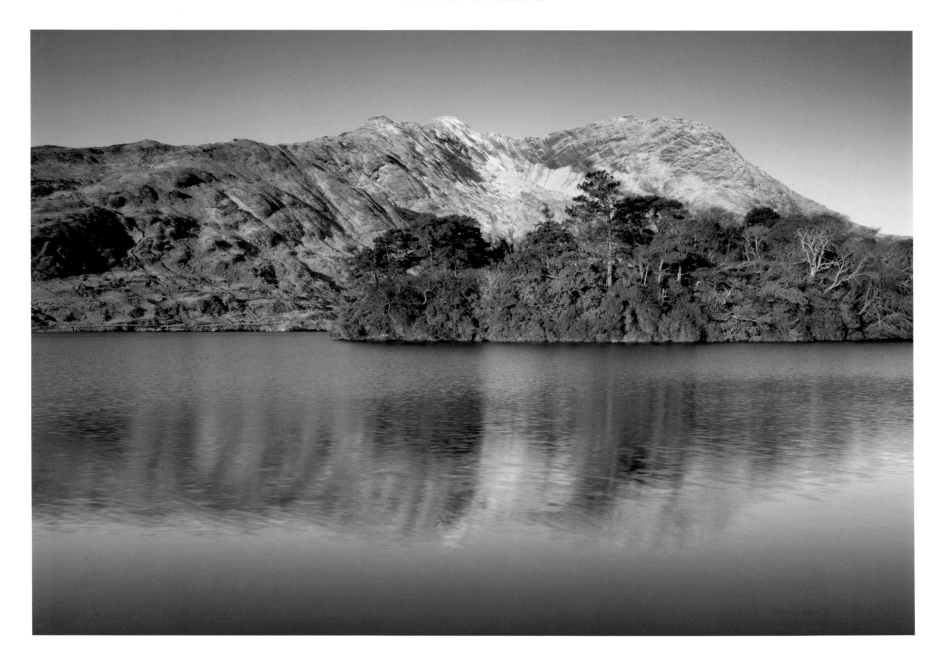

CLEAR DAY
Lough Fee, Connemara

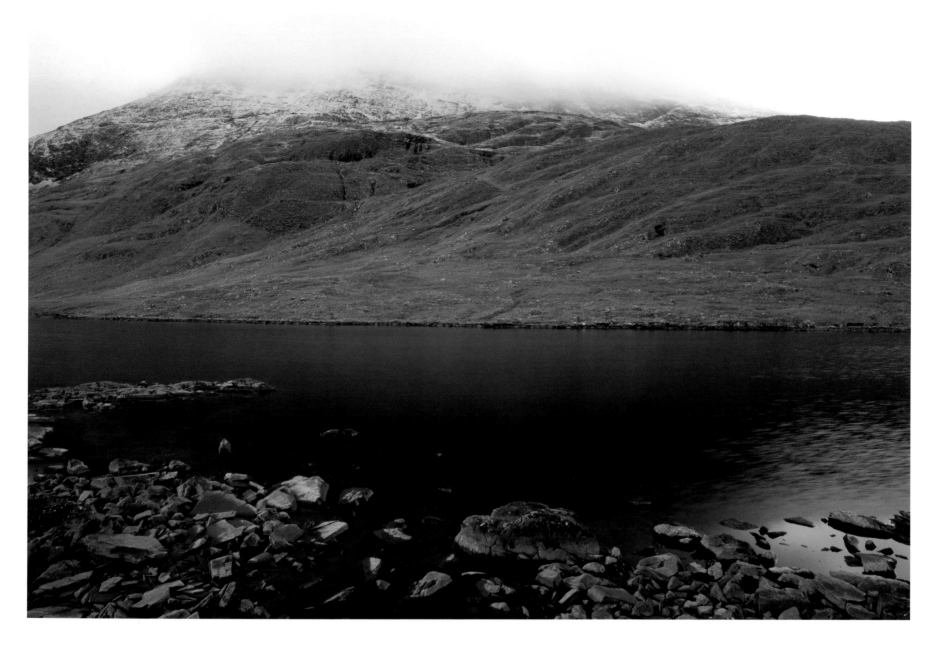

WINTER TWILIGHT
Lough Muck & Benchoona Mountain, Connemara

Killary Harbour is a great sea lough that cuts 15 km inland. Its name comes from the Irish 'Caol Rua', which means 'narrow red sea passage'. Killary is Ireland's only fjord. For many years, however, it was an ongoing discussion between geologists and geomorphologists whether Killary is a real fjord or merely a fjord-like inlet lacking the threshold that denotes a fjord. A survey in the 1970s finally showed a rock outcrop near the mouth of the bay that is now considered to be the required threshold. Today the sheltered bay has become a major tourist attraction with regular cruises starting from Leenaun and is used for mussel and salmon farming.

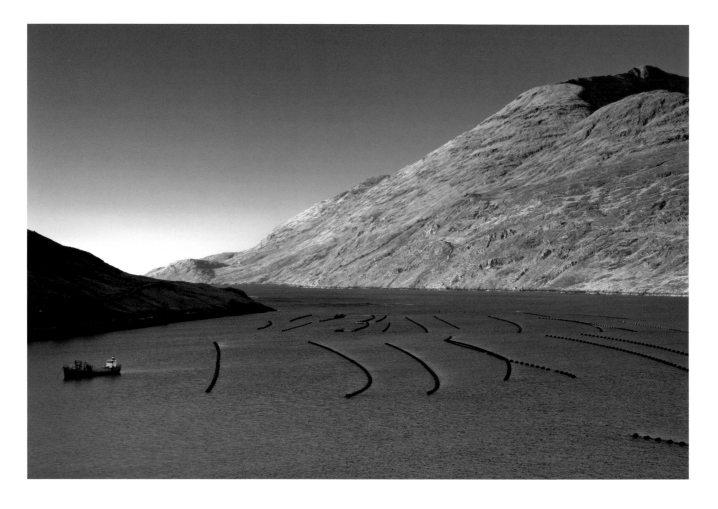

KILLARY HARBOUR I
Connemara

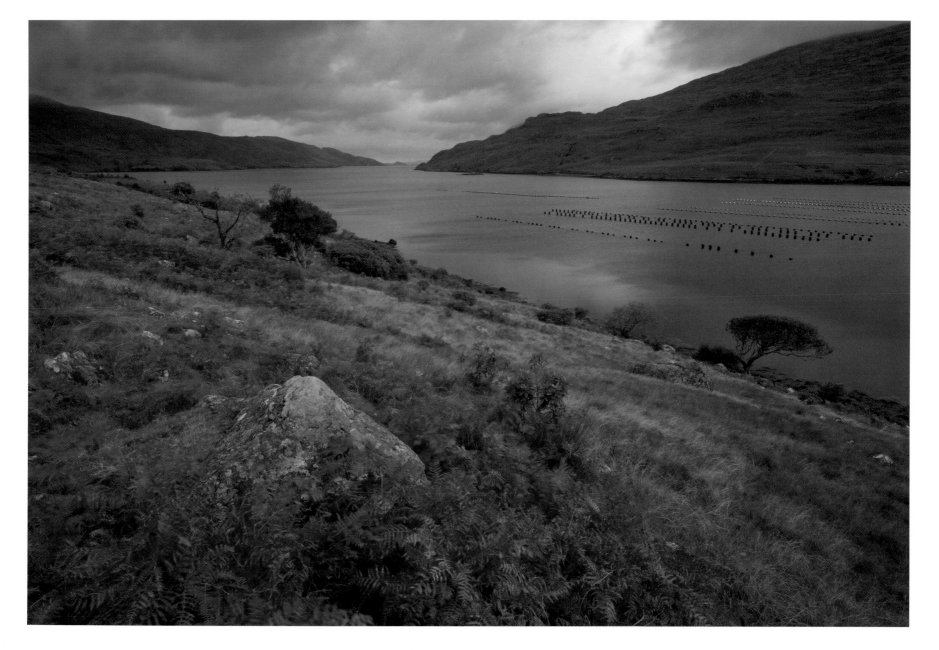

KILLARY HARBOUR II
Connemara

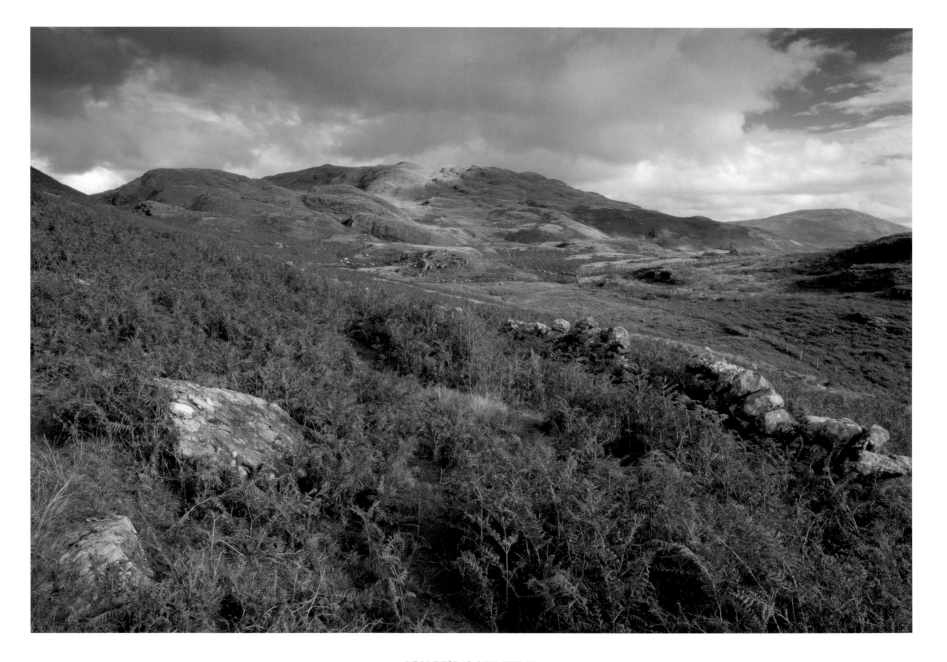

JOYCE'S COUNTRY
Glenbeg, Connemara

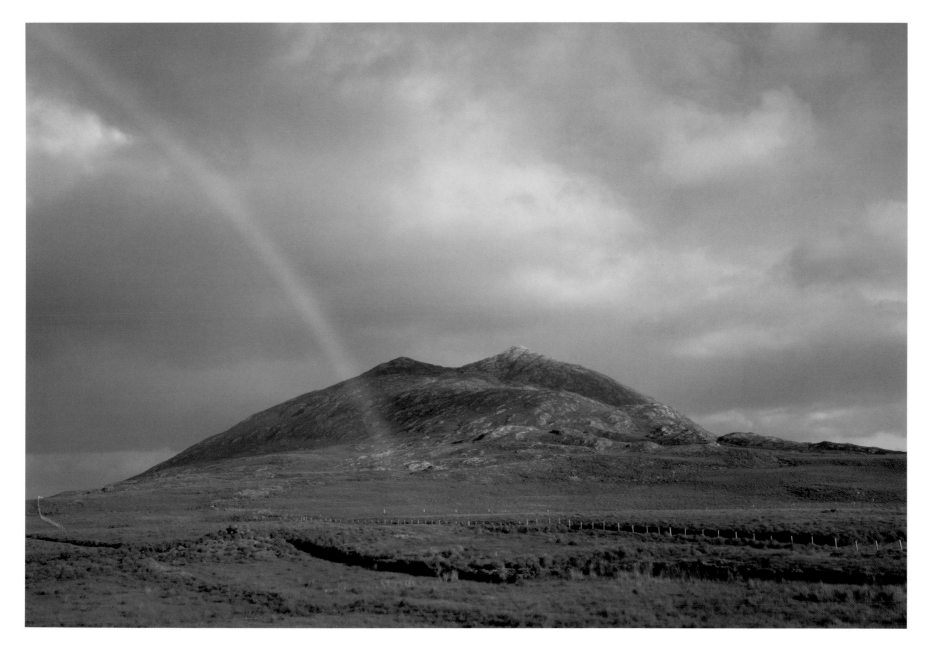

RAINBOW
Lackavrea Mountain, Connemara

LAKESHORE
Lough Nafooey, Connemara

LICHEN LANDSCAPE
Maumturk Mountains, Connemara

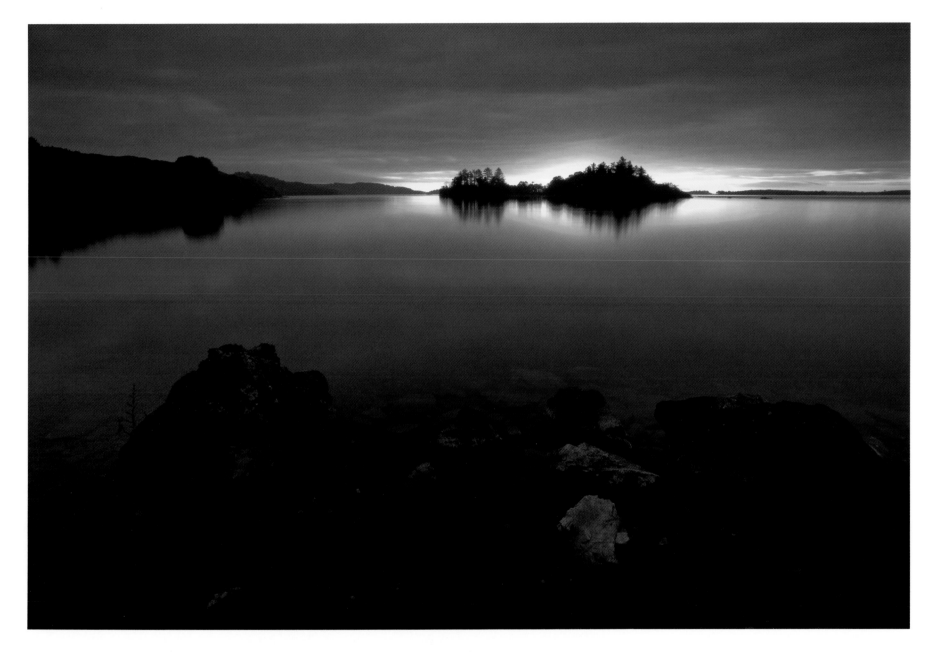

CORRIB DAWN
Lough Corrib, Connemara

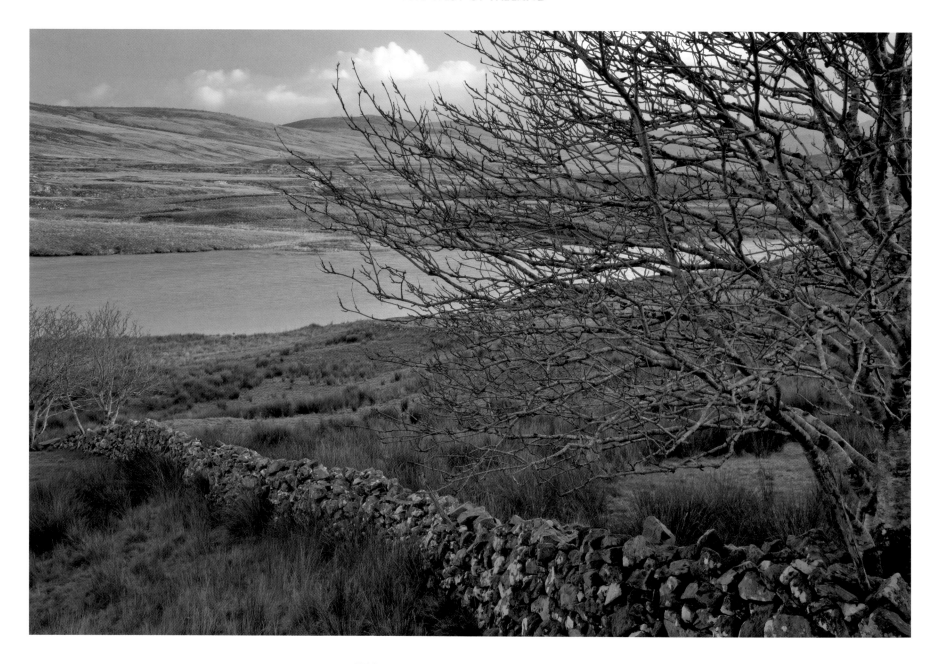

STONE WALL, ASH TREES & LAKE
Shanakeever Lough, Connemara

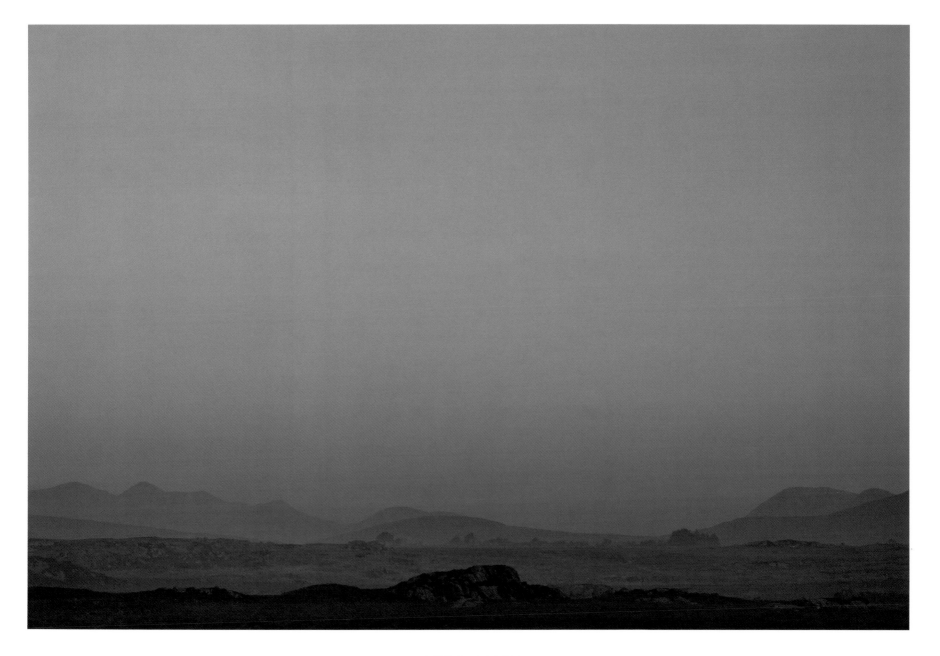

MISTY DAWN
near Casla, Connemara

TRAWLER
Barnaderg Bay, Connemara

WRECKAGE
Lough Inagh, Connemara

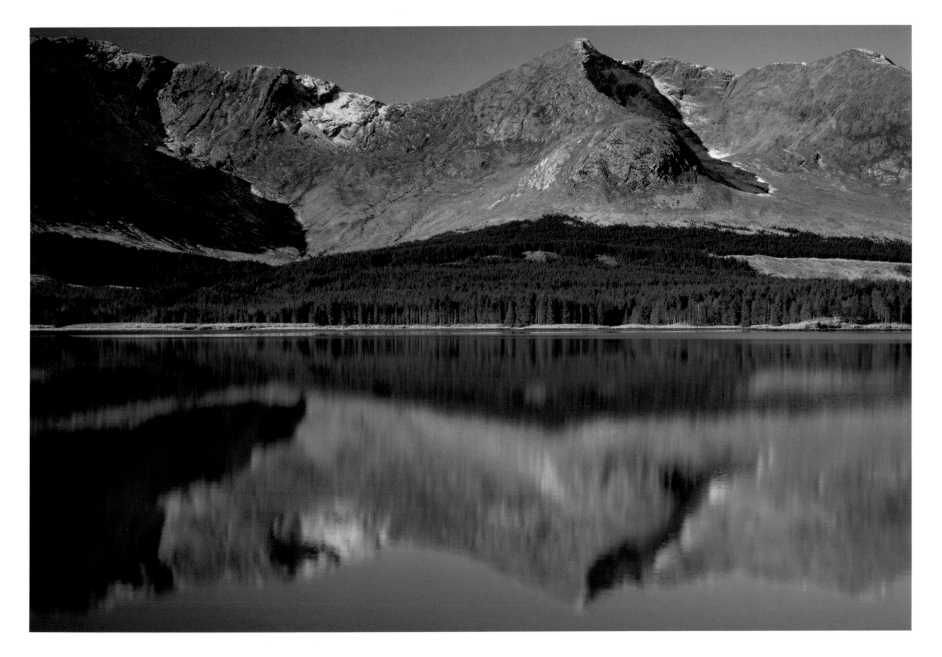

MOUNTAIN MIRROR
Lough Inagh & Twelve Bens, Inagh Valley, Connemara

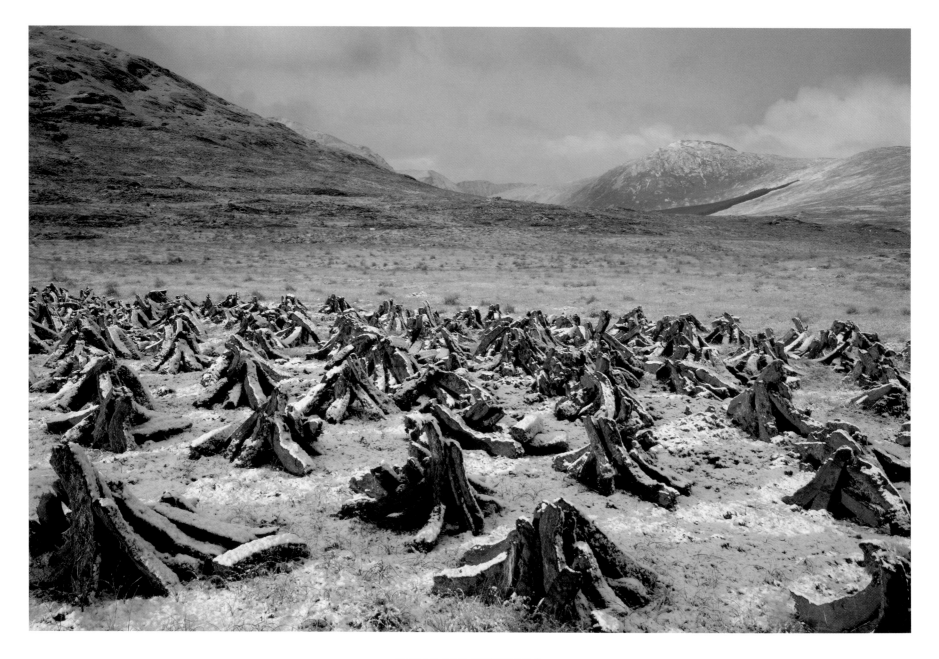

CLEARING BLIZZARD
Inagh Valley, Connemara

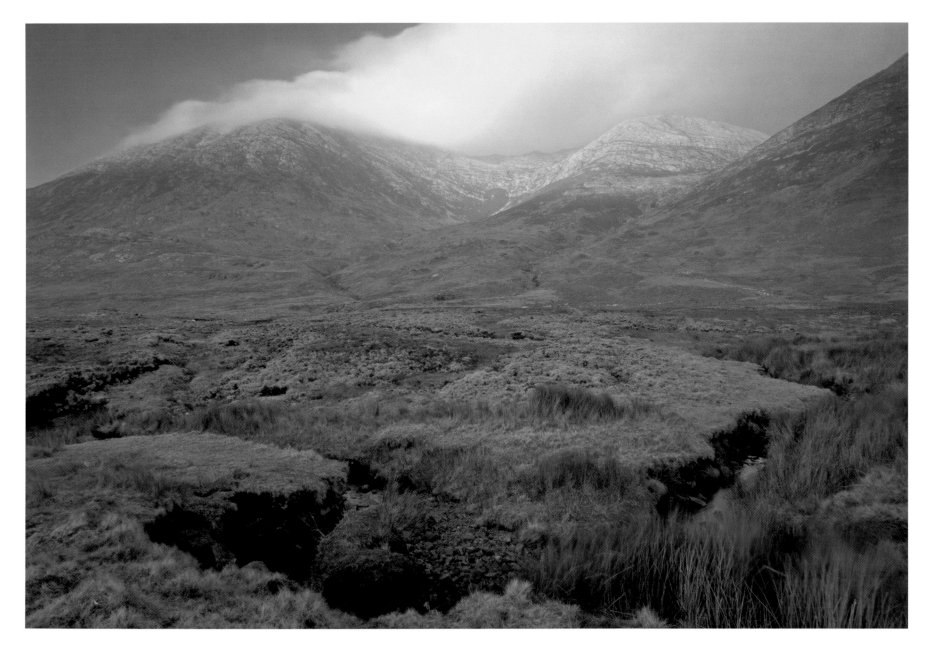

CLOUDS IN THE MOUNTAINS
Maumturk Mountains, Connemara

FROM DELPHI TO DOWNPATRICK HEAD

IN COUNTY MAYO

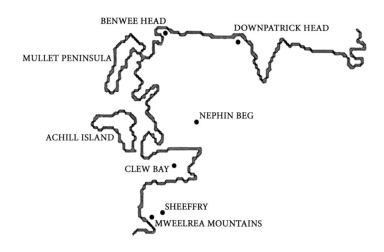

BENWEE HEAD

DOWNPATRICK HEAD

MULLET PENINSULA

NEPHIN BEG

ACHILL ISLAND

CLEW BAY

SHEEFFRY

MWEELREA MOUNTAINS

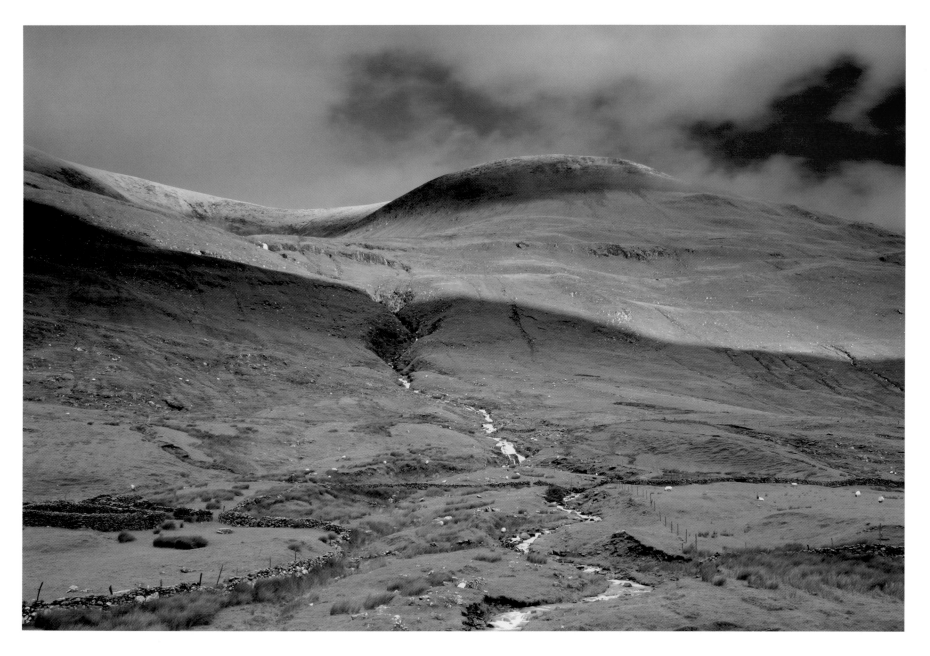

WINTER MORNING
Sheeffry Hills

County Mayo is the wildest and remotest part of the west. The Mayo coast is a mixture of sandy beaches and mighty cliffs. Among the latter are some of the highest sea cliffs in Europe rising to a height of more than 600 m. Achill Island, which has been connected to the mainland by a bridge since 1888, and the Mullet Peninsula are two outposts that almost form a barrier to protect the mainland from the forces of the Atlantic Ocean.

Away from the coast a carpet of blanket bog covers the land like a damp coat that is overlooked by stately mountain ranges. The Mweelrea Mountains, the Sheefry Hills and the Partry Mountains form a border with County Galway to the south. Croagh Patrick, Ireland's holy mountain, watches over Clew Bay and its many islands. Further north beyond Clew Bay, the Nephin Beg Range is the last rise before a wide plain stretches all the way to the Atlantic Ocean. Here in the north of Mayo the blanket bog expands for mile after mile and makes this probably the most desolate place in Ireland.

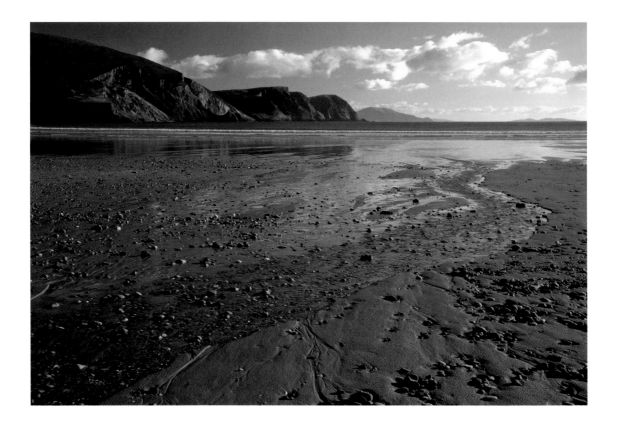

KEEL BEACH
Trawmore, Achill Island

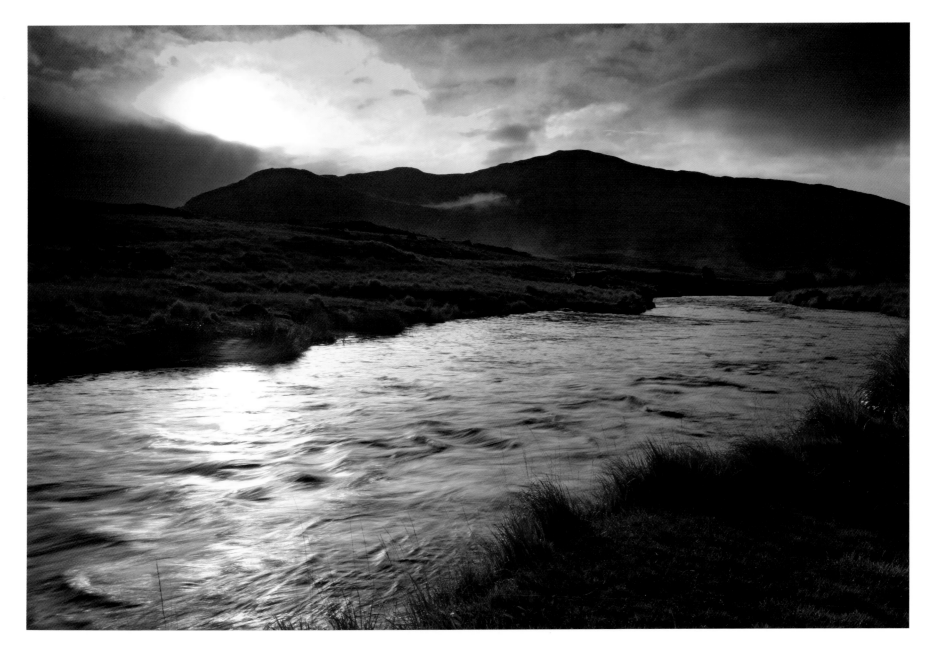

CLEARING WEATHER
Bundorragha River, Delphi

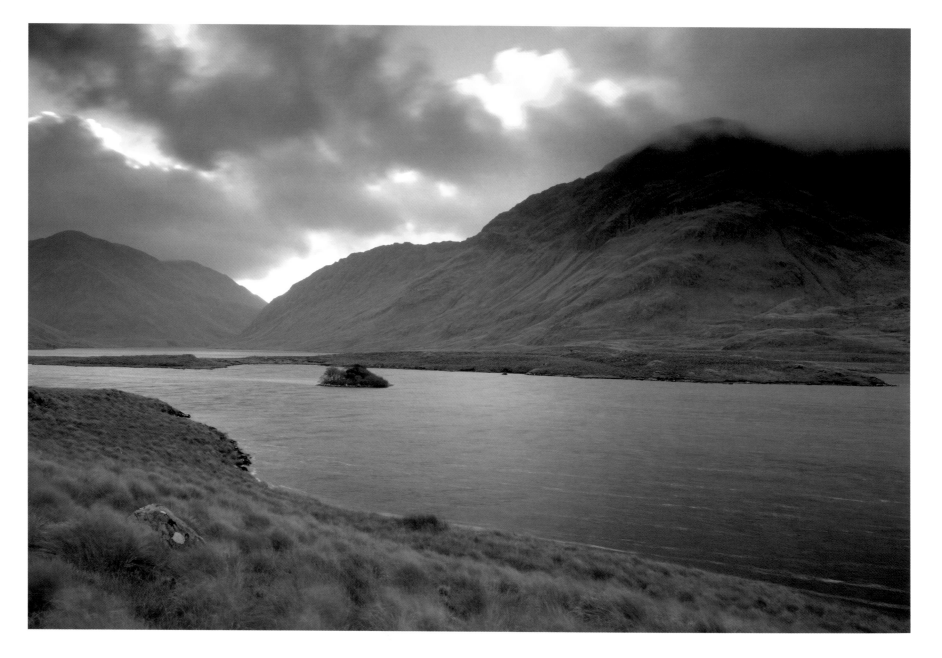

DOOLOUGH
Mweelrea Mountains

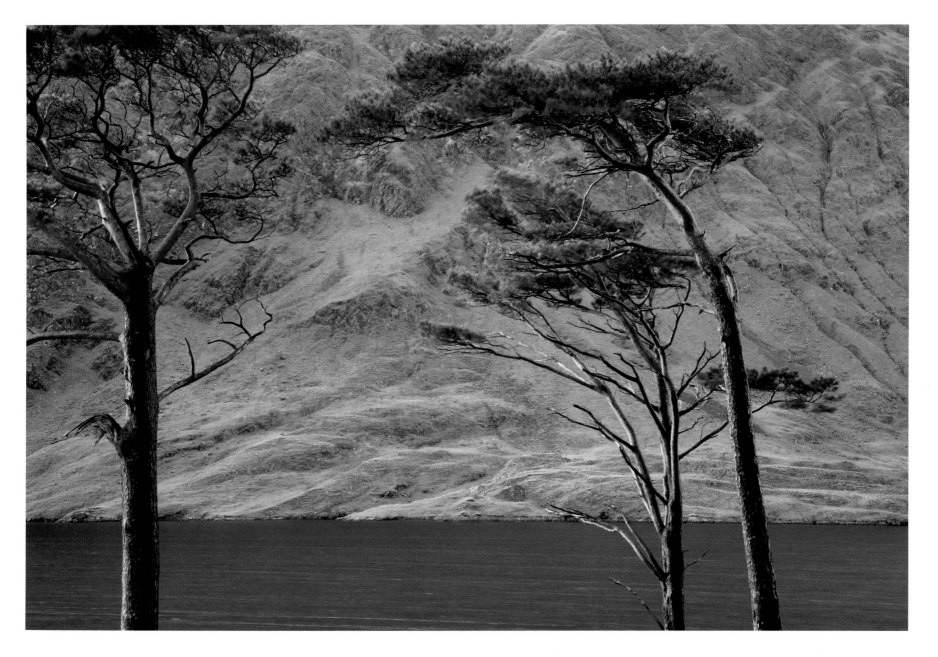

THREE TREES
Doolough

The southwest of County Mayo is an expansive range of mountains. The Mweelrea Mountains, the Sheefry Hills and Ben Gorm are among the most beautiful places in Ireland. Only a few minor roads penetrate this wilderness and make the landscape photographer's work both challenging and rewarding.

In contrast to the wild beauty of the area the shadow of one of the greatest tragedies in Irish history still hangs over these mountains. At the height of the Great Famine 600 starving people were seeking admission to the workhouse in Louisburgh. They were turned away and sent to Delphi where two paid Poor Law guardians were holding a meeting the next day. In the morning 400 people, barefoot and in poor clothing, set out on a wet and bitter cold spring day. On the way the people had to make their way along exposed mountainside, soggy blanket bog and had to ford streams and rivers that were swollen by recent rainfalls. When they finally reached Delphi Lodge, soaked, freezing and starving, the guardians who had just finished their dinner, refused help and sent them back to Louisburgh. Back then there were no roads through that grim mountain pass between the Mweelrea Mountains and the Sheefry Hills, just narrow tracks high above Doo Lough. Night was falling when the 400 people started their way back to Louisburgh and high winds brought hail and sleet showers. Sudden gusts drove many people off the cliffs, others drowned while crossing the torrential Glenkeen River. None of the 400 survived.

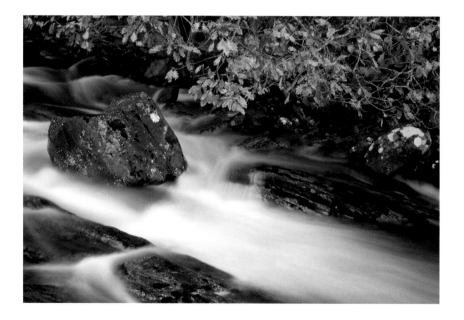

GLENLAUR RIVER
Sheeffry Hills

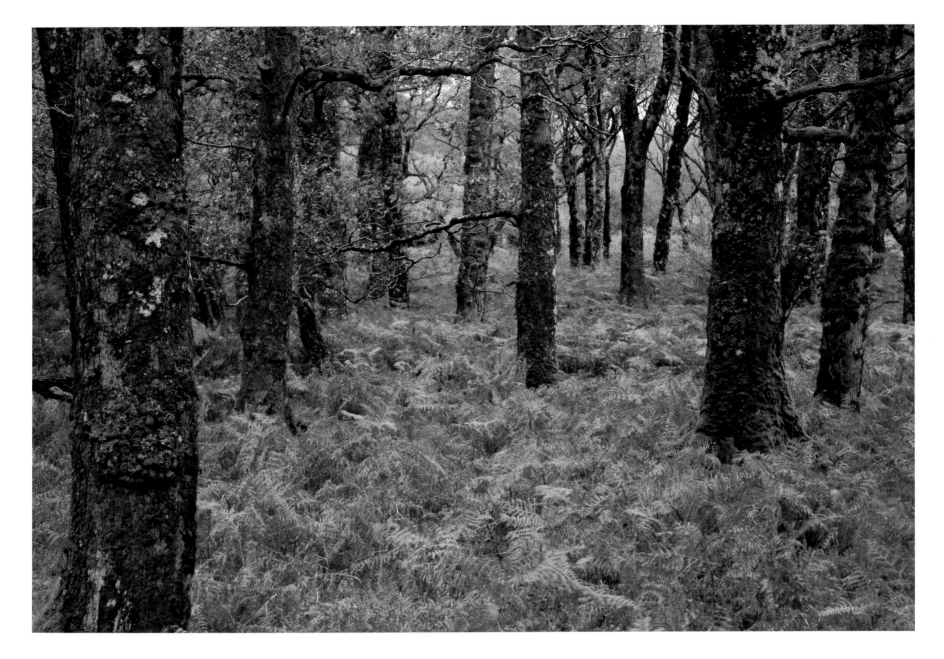

AUTUMN FOREST
Sheeffry Wood

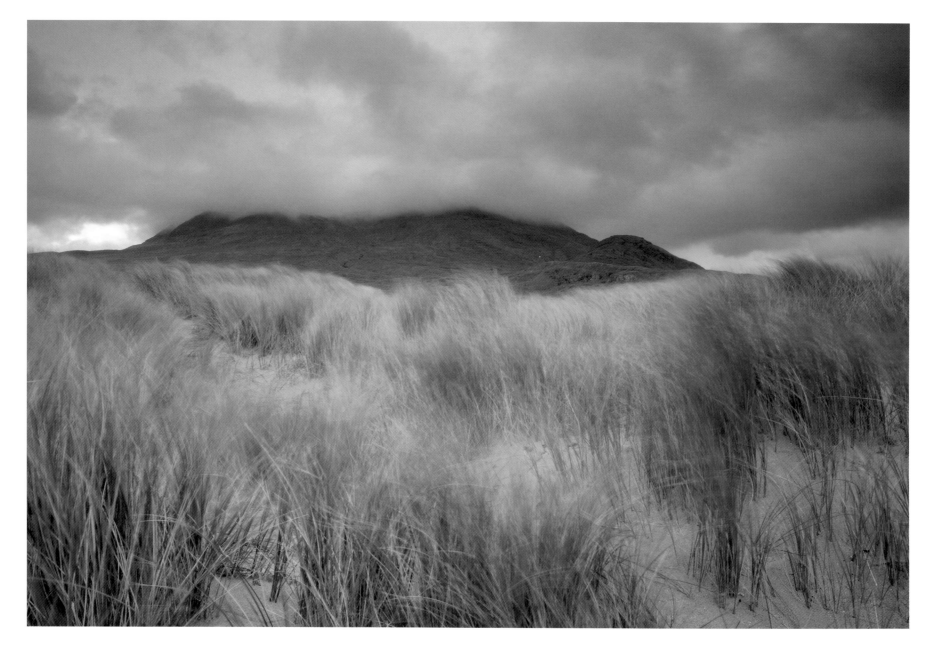

WEATHER ON MWEELREA
Silverstrand

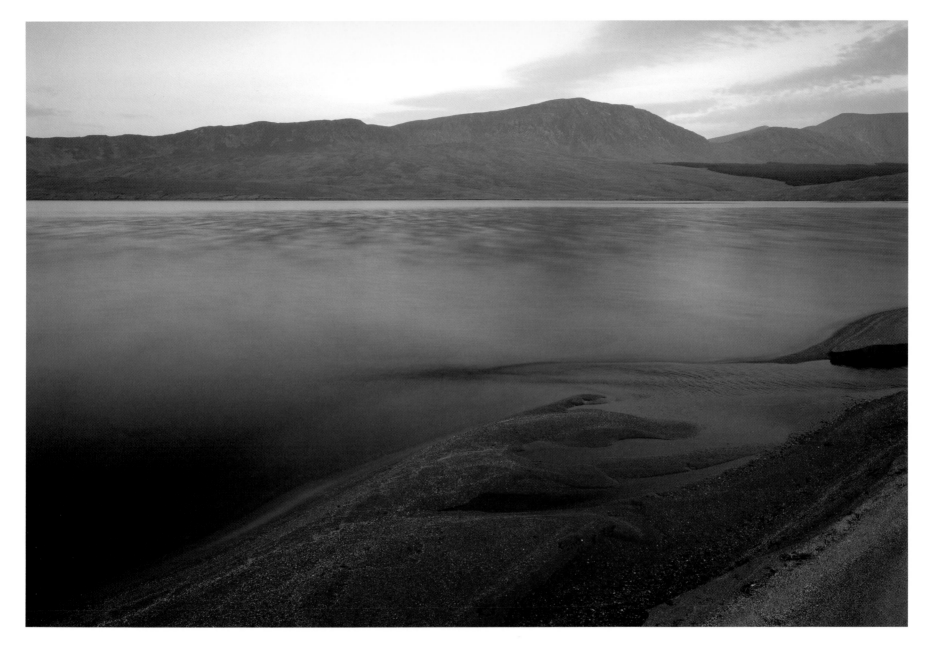

LOUGH FEEAGH
Nephin Beg

Clew Bay stretches from Roonagh Point in the south to Corraun in the north. Legend has it that there are 365 islands in the bay, one for every day of the year. These islands are drumlins, small hills of earth and rock that were deposited by the ice pushing out from its inland domes during the last ice age. When the glaciers melted and sea levels rose the drumlins became partly submerged.

Watching over the bay is Croagh Patrick, Ireland's holy mountain. Better known locally as the Reek it is a true landmark and its distinctive peak can be seen from all directions. The Reek is obviously named after St Patrick who retired to the mountaintop to fast and pray for forty days and nights. During that time it is said he banished from Ireland all the snakes and demons, all the pagan gods and spirits.

The tradition of going on a pilgrimage to climb Croagh Patrick is still very much alive. In the past the annual pilgrimage was done on the night before the last Sunday in July. It was a dangerous undertaking as even in daylight the climb is not an easy one and the final part where the pilgrims have to conquer a gravel field can be dangerous. Today the pilgrimage takes place during daytime. Thousands of people climb the mountain, some barefoot or on their knees, following the Stations of the Cross to listen finally to mass held in the small chapel at the summit.

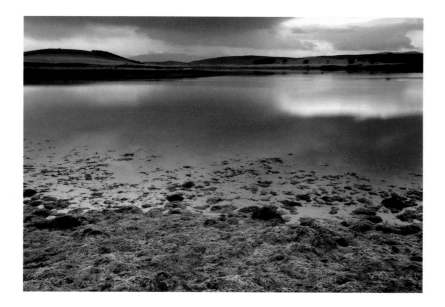

CLEW BAY I
Westport

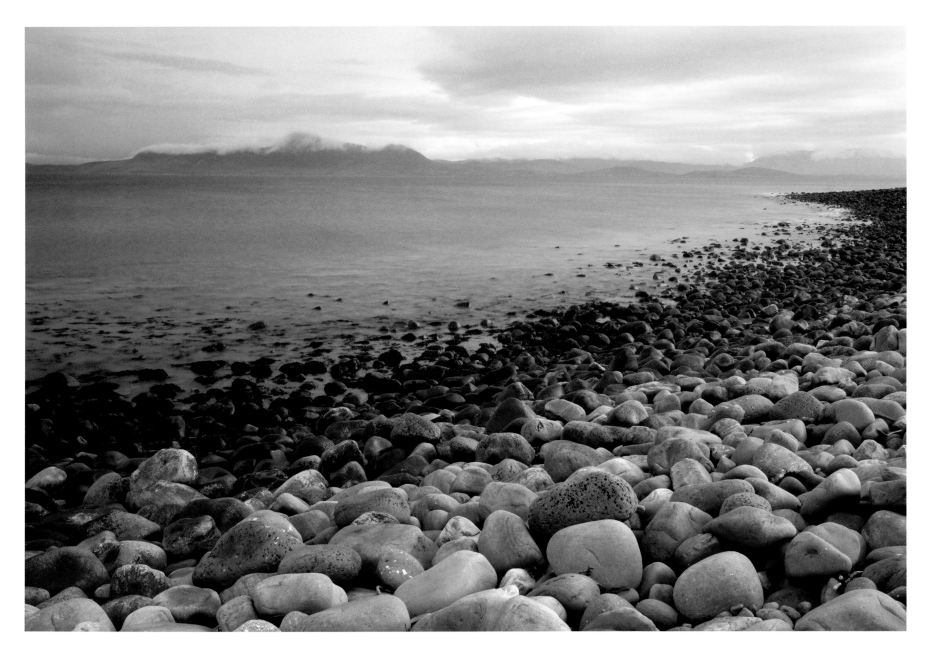

CLEW BAY II
Mallaranny

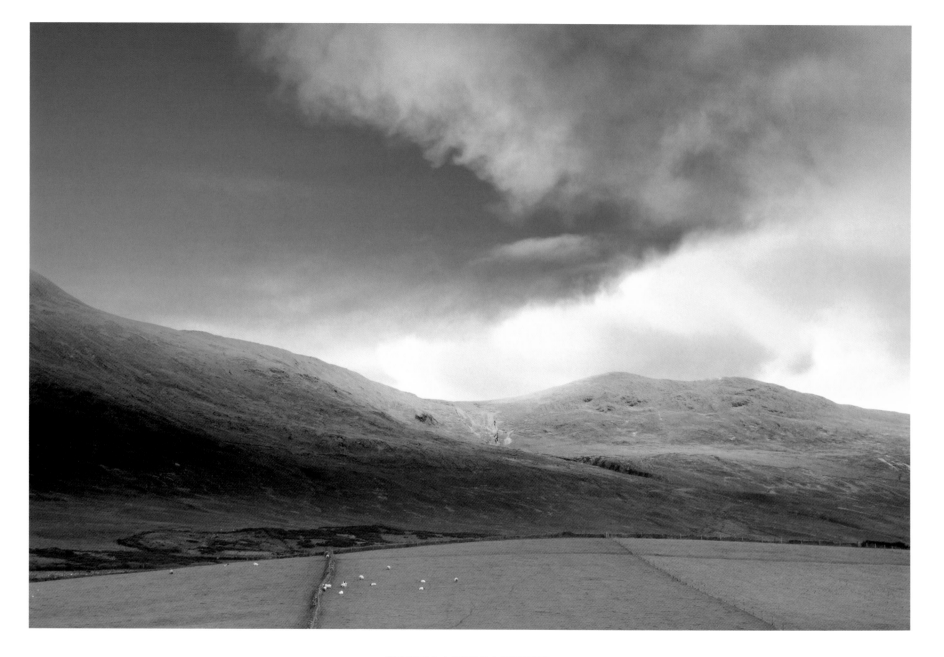

STORM APPROACHING
Ben Gorm, Clew Bay

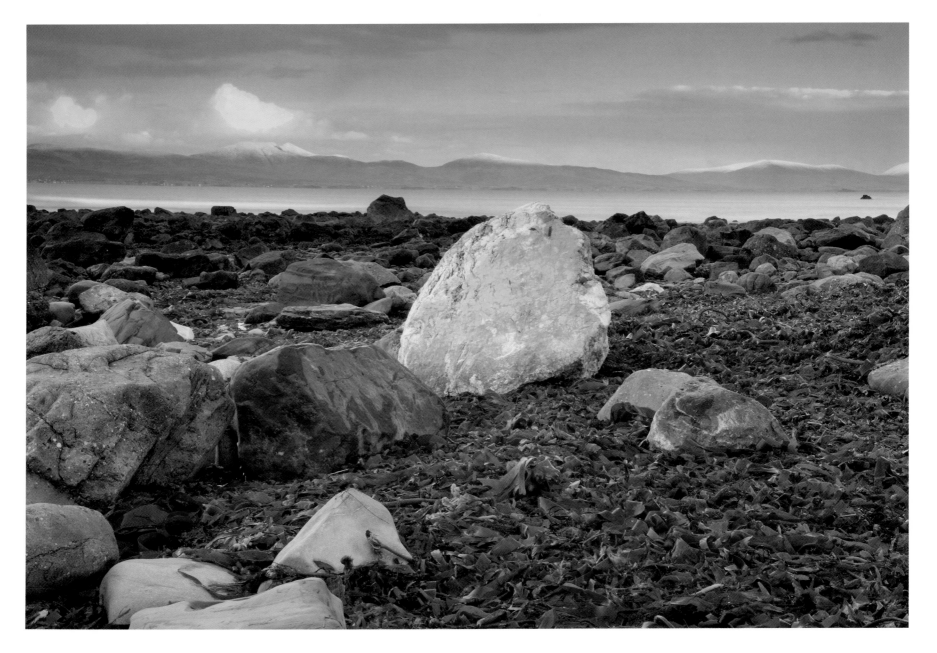

BUNOWEN BEACH
Clew Bay

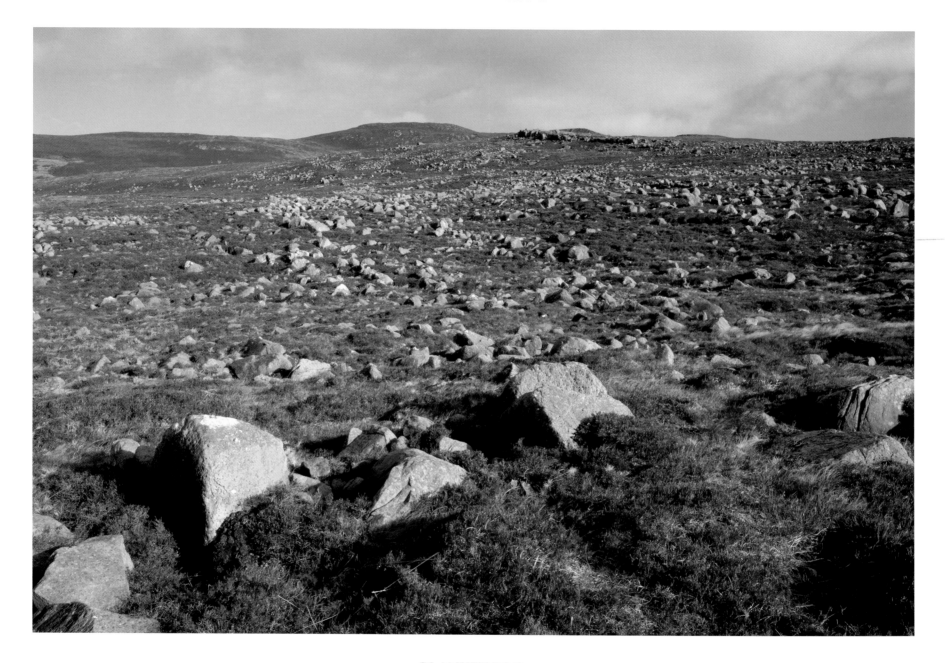

BLANKET BOG
Corraun Hill, Achill

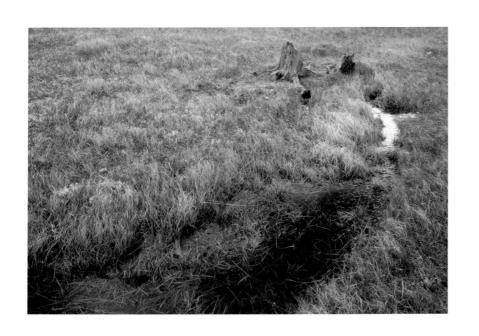

BOG PINE
Achill Island

TURF BANK
Achill Island

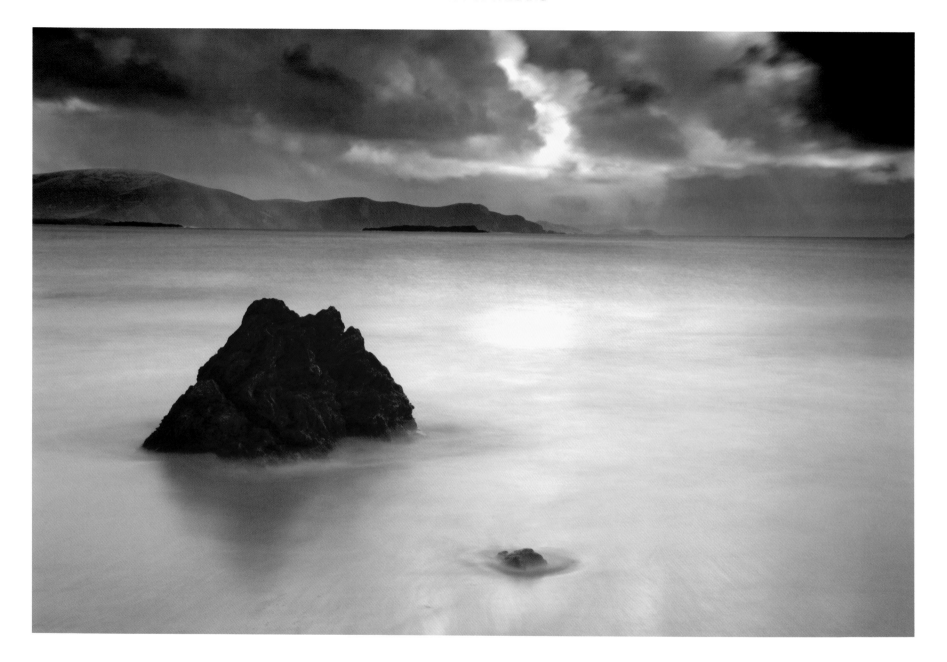

STORM CLOUDS
Keem Strand, Achill Island

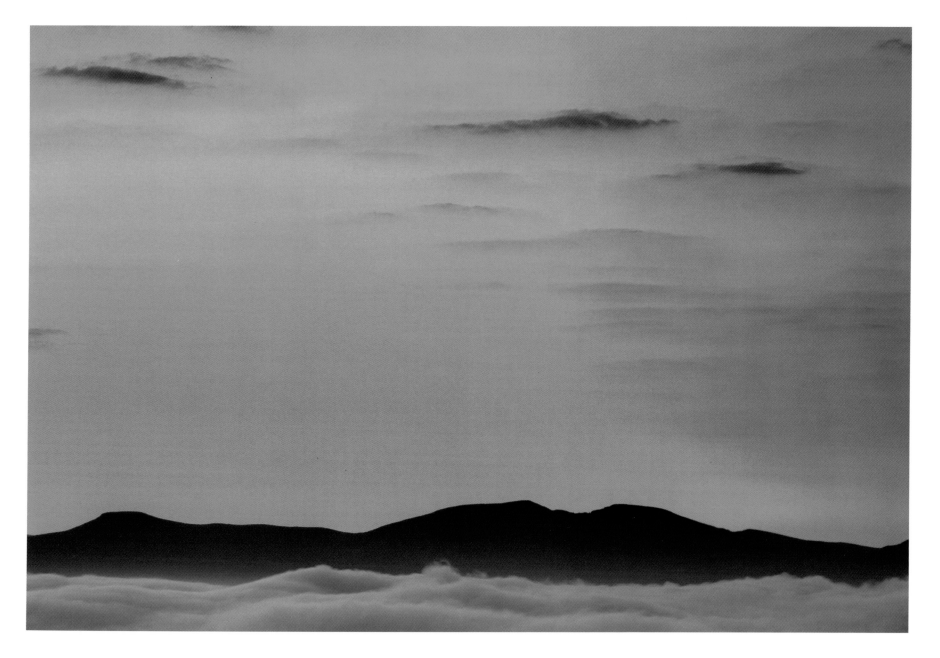

CLOUDS, MOUNTAINS, DAWN
Nephin Beg Range from Achill Island

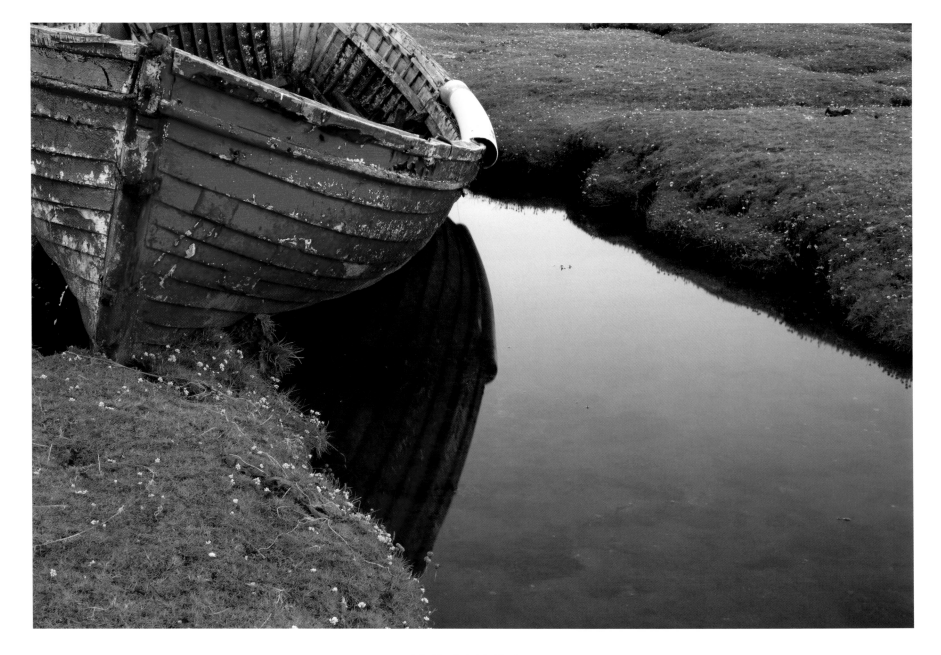

BOAT & MACHAIR
Broadhaven

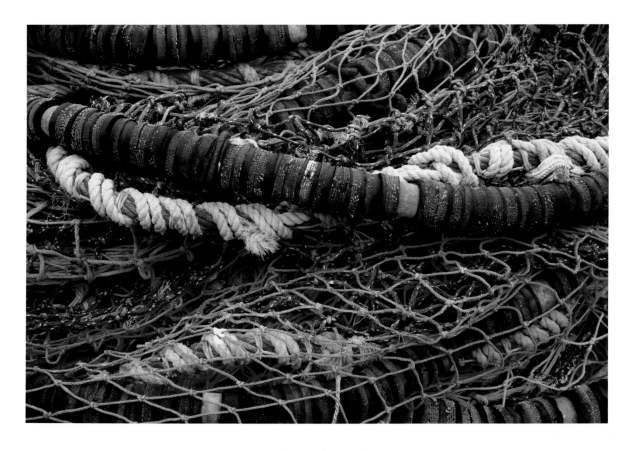

FISHING NETS
Achill Island

BOATS
Corraun Harbour

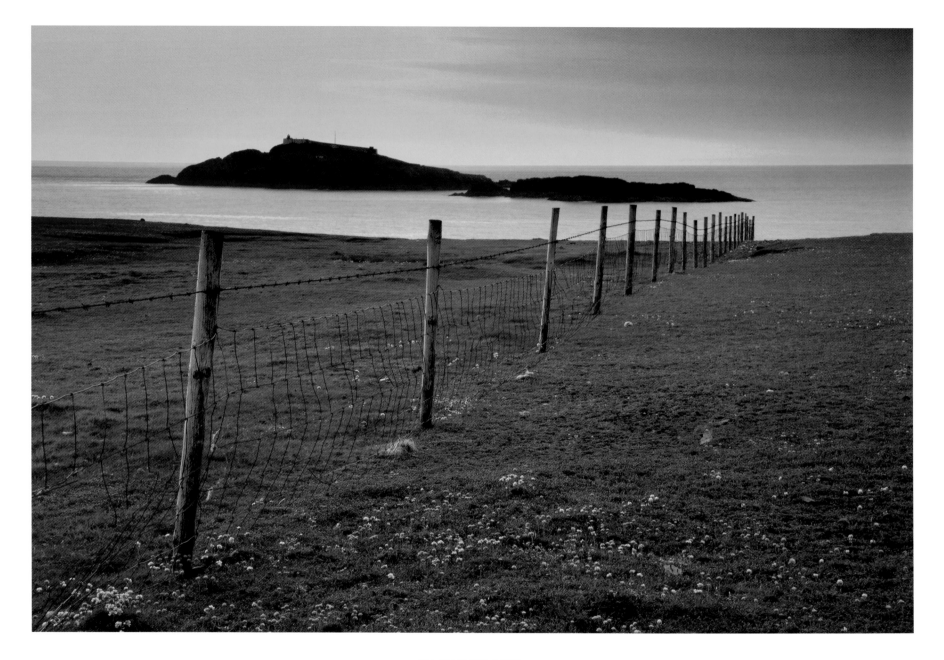

EAGLE ISLAND
Mullet Peninsula

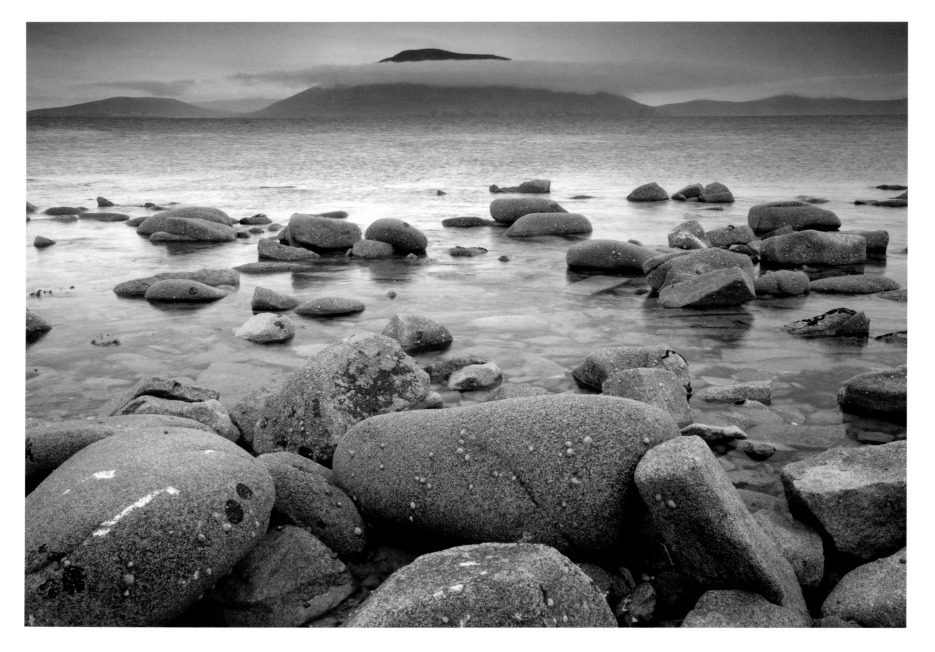

SLIEVEMORE IN CLOUDS
Blacksod Bay, Mullet Peninsula

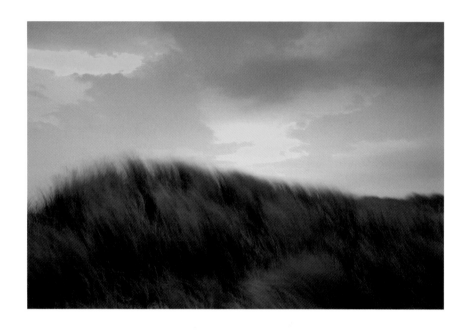

DUNES AT DAWN
Barnynagappul Strand, Achill Island

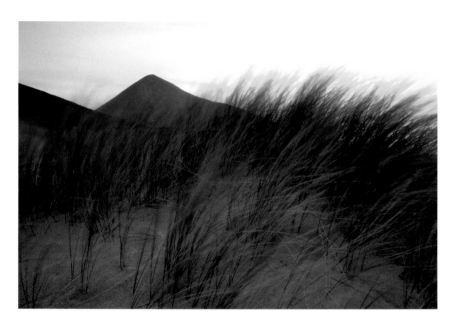

SLIEVEMORE
from Barnynagappul Strand, Achill Island

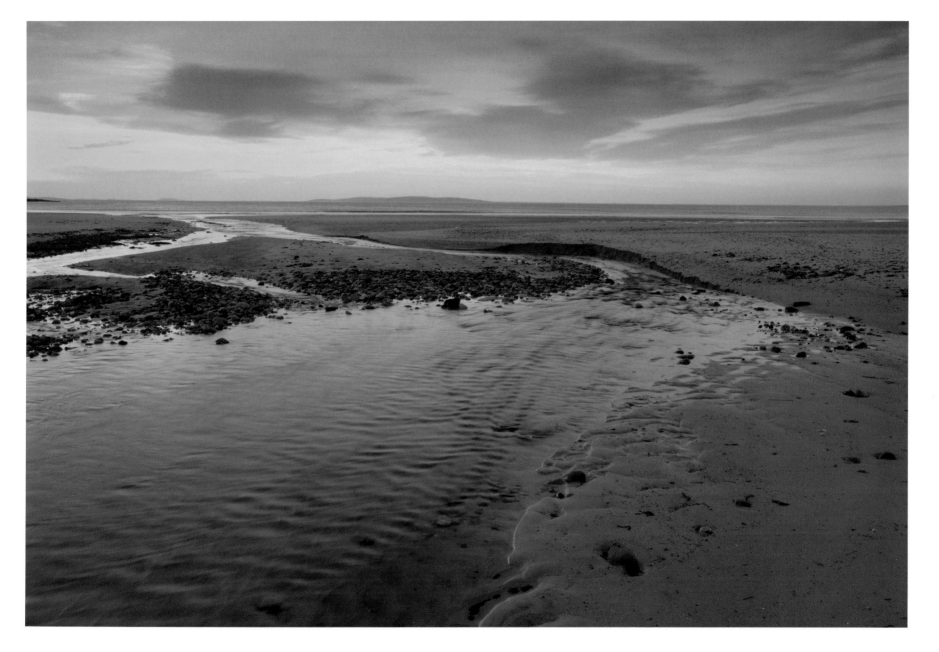

BARNYNAGAPPUL STRAND
Achill Island

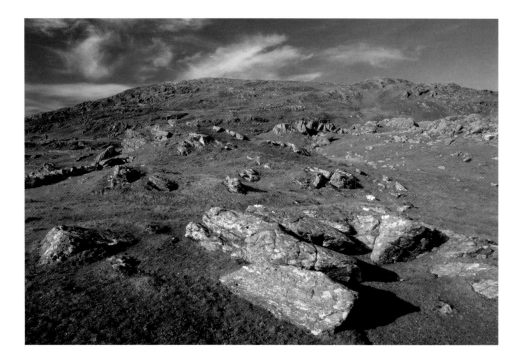

EARLY SPRING
Carrowgarve, Achill Island

Achill Island is one of those places where time seems to stand still. There is always a tranquil mood hovering over the landscape even in the height of summer when the island is packed with visitors. On my first visit low clouds and a soft but constant drizzle had covered the island. After driving around for a while taking in the melancholic mood of the place and the day I ended up at the Deserted Village. A row of ruined cottages with only the foundation walls remaining is nestled at the foot of Slievemore Mountain. In front of the ruins stone walls dividing the fields and the outlines of the lazy beds are still visible. The mountain in the background is shrouded in clouds. That day and that place will always represent the history of the west for me. Hardship, famine, despair and death are still very present here.

Another visit some years later could not have been more different. Glorious sunshine and blue skies transformed Achill Island into a Mediterranean paradise. This kind of weather is not what a landscape photographer is looking for so I spent the day relaxing at what is probably Ireland's most beautiful beach, Keem Strand, baking in the sunshine and hoping for some bad and dramatic weather to return.

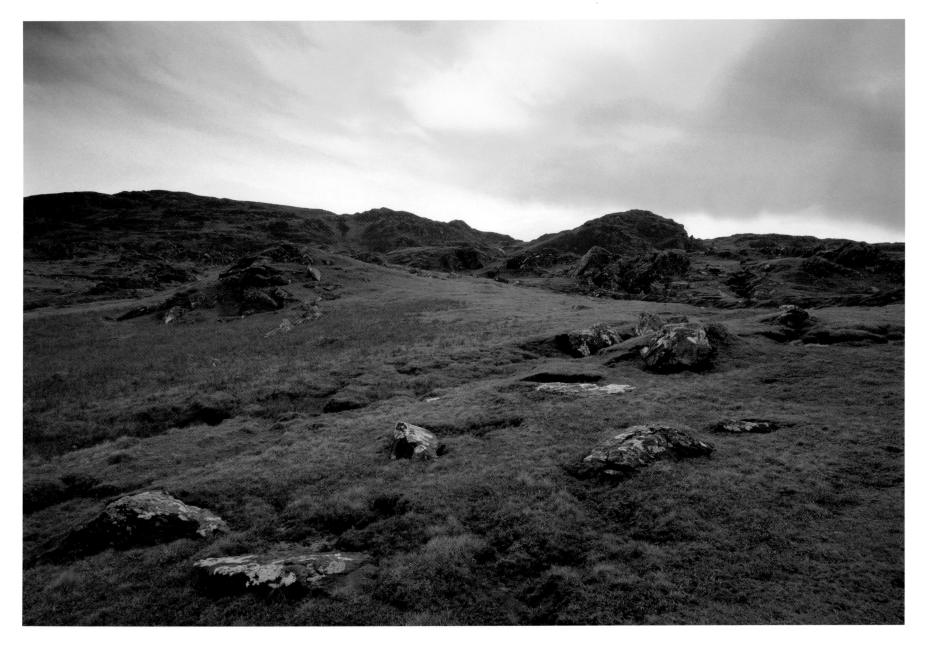

STORM LIGHT
Claggan, Achill Island

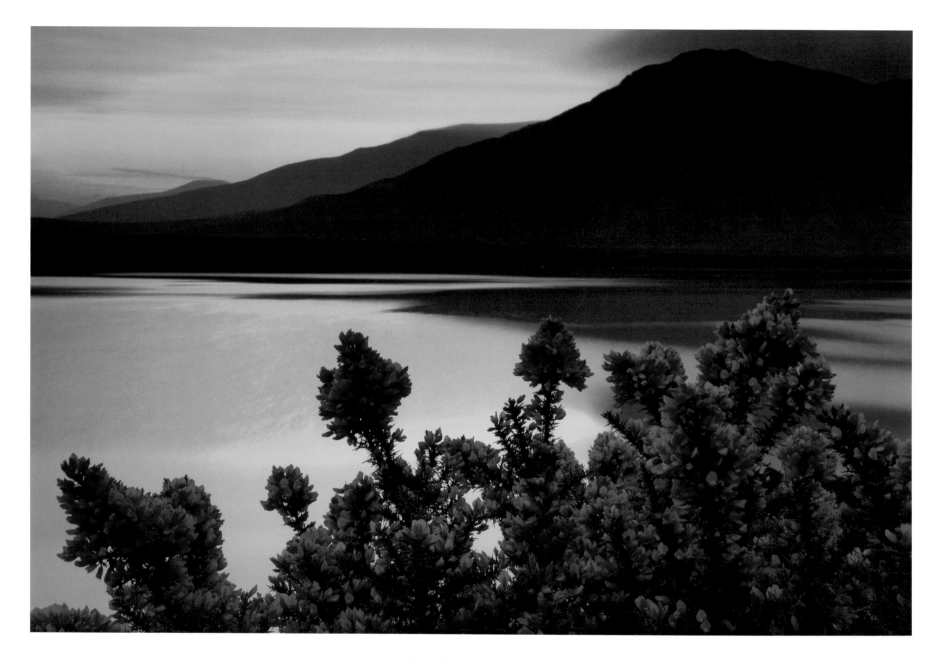

SPRING MORNING
Bellacragher Bay

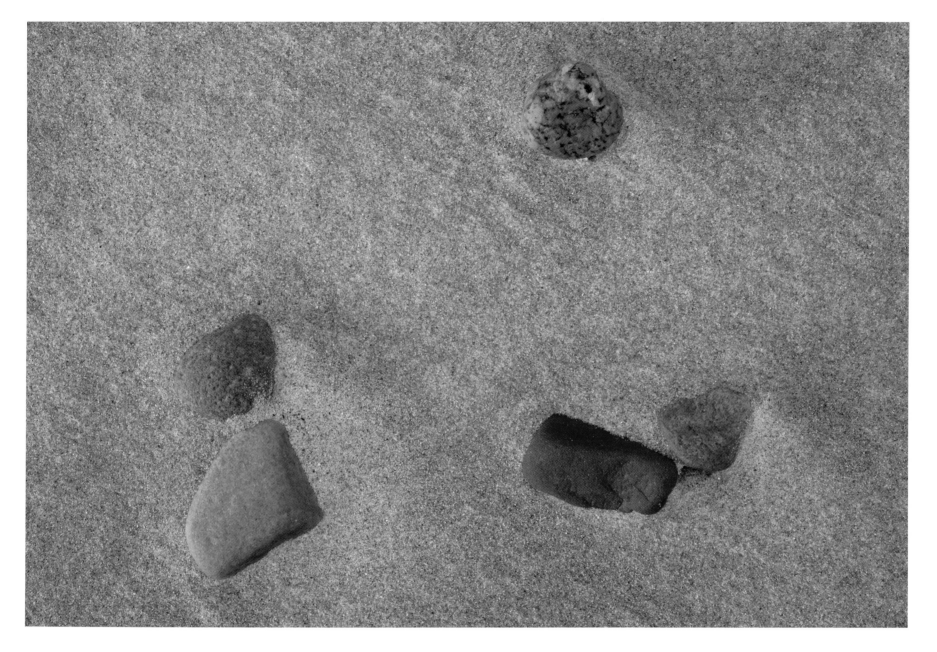

PEBBLES
Barnynagappul Strand, Achill Island

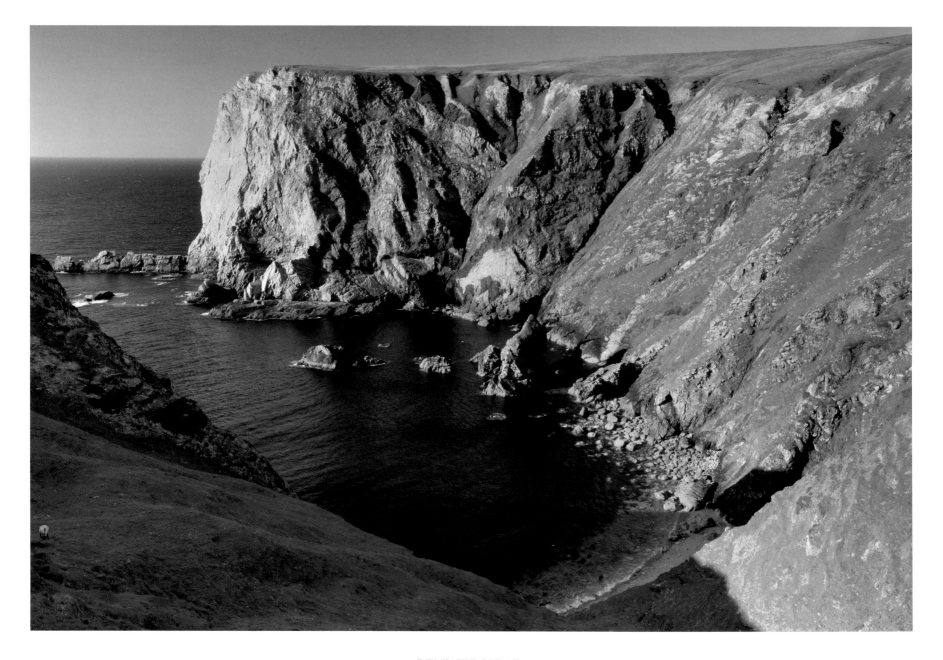

BENWEE HEAD
North Mayo

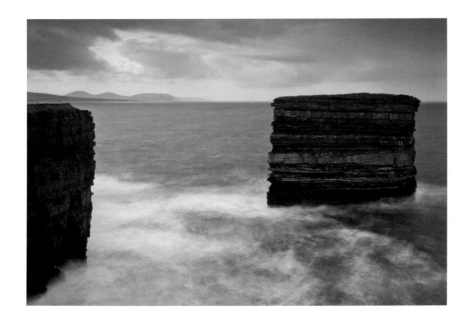

NORTH MAYO COASTLINE
Downpatrick Head

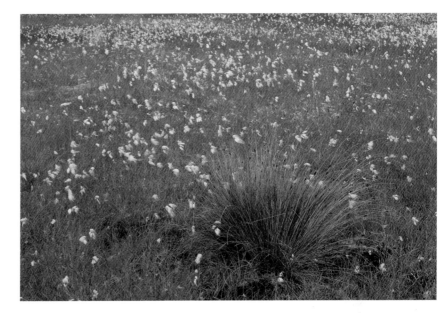

BOG COTTON FIELD
Erris

North Mayo has been the scene of a silent battle for some years now. The Corrib Gas Field was discovered off the north Mayo coast in 1996 and the Shell Company was granted the rights to exploit the gas.

Unlike the usual practice Shell was planning to bring the unprocessed gas onshore and process it at a purpose-built refinery inland. Beside the environmental damage that would be caused by this building project, the pipeline carrying unprocessed raw gas would run through private land and close to people's houses, something that has not been tried anywhere and poses huge risks for the inhabitants of the area.

Most local people opposed Shell's plan and formed the Shell to Sea campaign. When a group of local landowners, now known as the Rossport Five, actively denied Shell access to their land they were arrested and jailed. This event caused the Shell to Sea campaign to receive nationwide interest and support. Regular demonstrations and protests were being held and forced Shell to stop their work for a considerable amount of time. At the time of writing the Shell to Sea campaign is still ongoing and no solution has been reached.

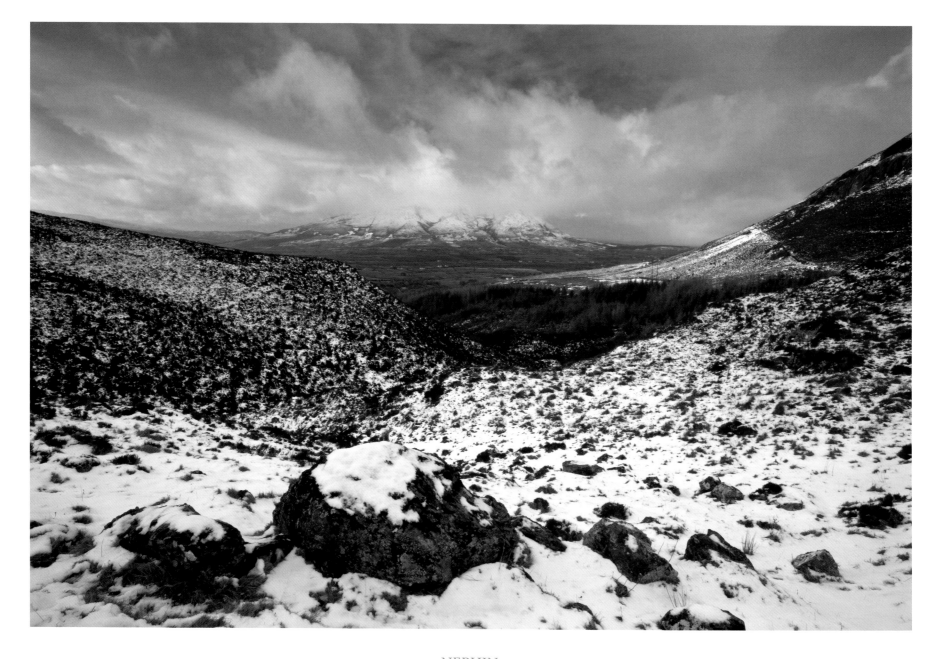

NEPHIN
Barnageehy/Windy Gap

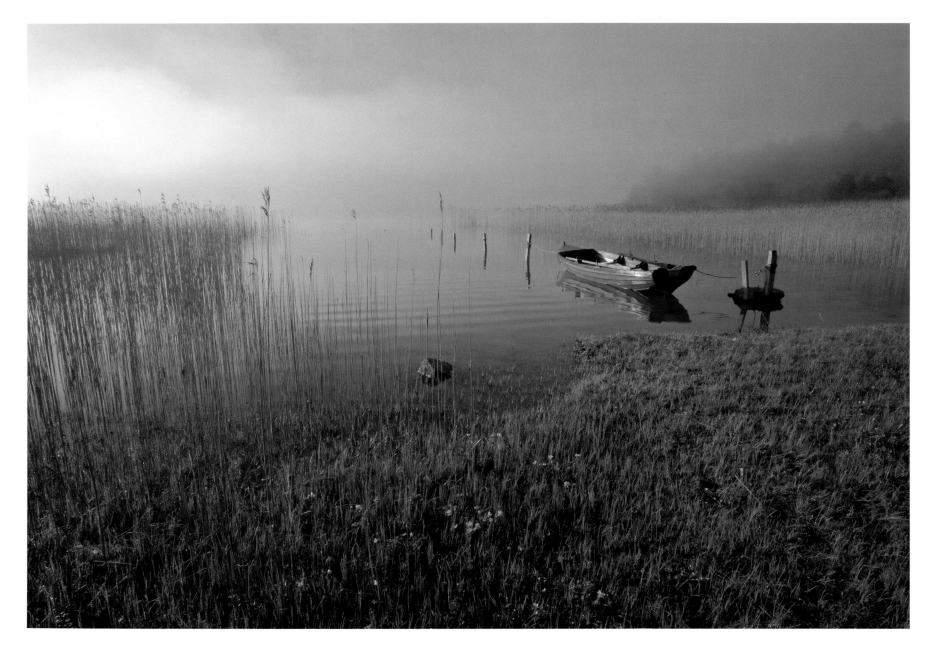

FOG LIFTING
Lough Cullin

HIDDEN TREASURES

COUNTY SLIGO AND COUNTY LEITRIM

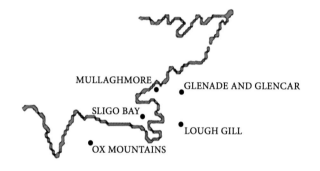

MULLAGHMORE

GLENADE AND GLENCAR

SLIGO BAY

LOUGH GILL

OX MOUNTAINS

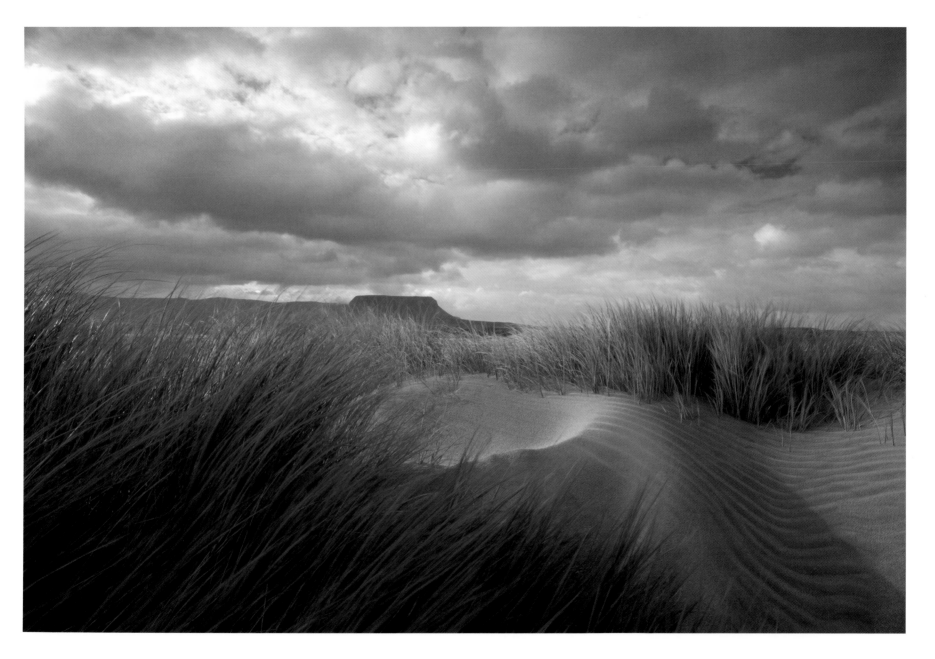

BEN BULBEN VIEW
Streedagh Beach, County Sligo

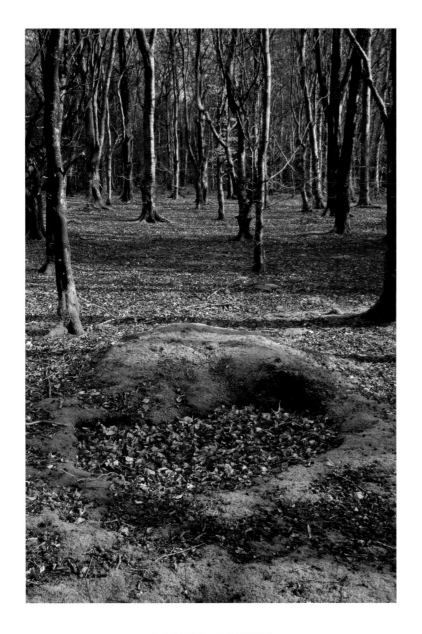

The counties of Sligo and Leitrim are a very special place. It seems like all the best features of the Irish landscape have been neatly arranged into these two small counties. There is a wild coastline with dramatic rocky shores and cliffs and beautiful sandy beaches. There are also brooding hills, majestic mountains and deep wooded glens, tranquil lakes and gentle rivers.

Maybe this unique landscape is the reason that Sligo and Leitrim are imbued with myth and legend like no other place in Ireland. And it is also no wonder that one of Ireland's finest poets, W. B. Yeats, saw Sligo as the land of his heart's desire. Although he was born in Dublin and spent most of his life in London, he considered Sligo his home and according to his wish he is buried in the shadow of Ben Bulben.

'Cast a cold Eye, on Life, on Death. Horseman pass by!'
(W. B. Yeats, from 'Under Ben Bulben', the epitaph on his grave at Drumcliff).

WINTER FOREST
Hazelwood, Lough Gill, County Sligo

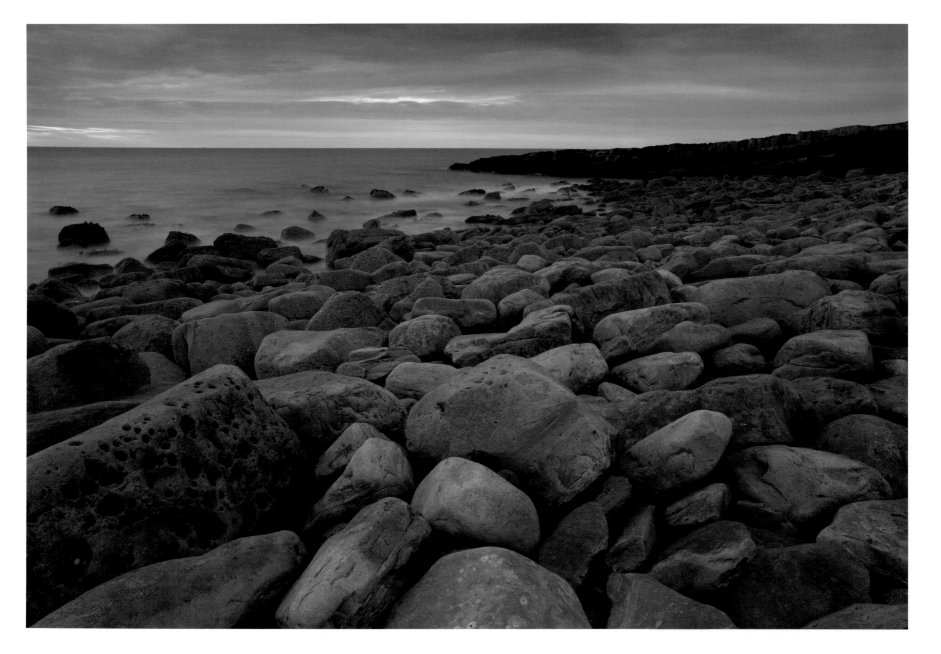

BOULDER COAST
Illaunee Beg, Mullaghmore, County Sligo

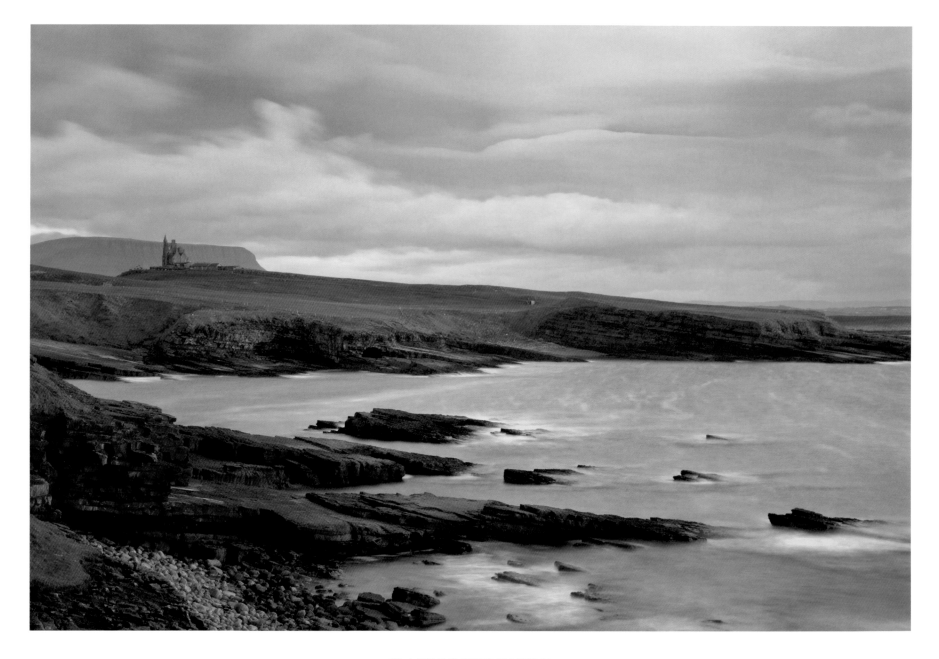

CLASSIE BAWN CASTLE
Mullaghmore, Illaunee Beg, County Sligo

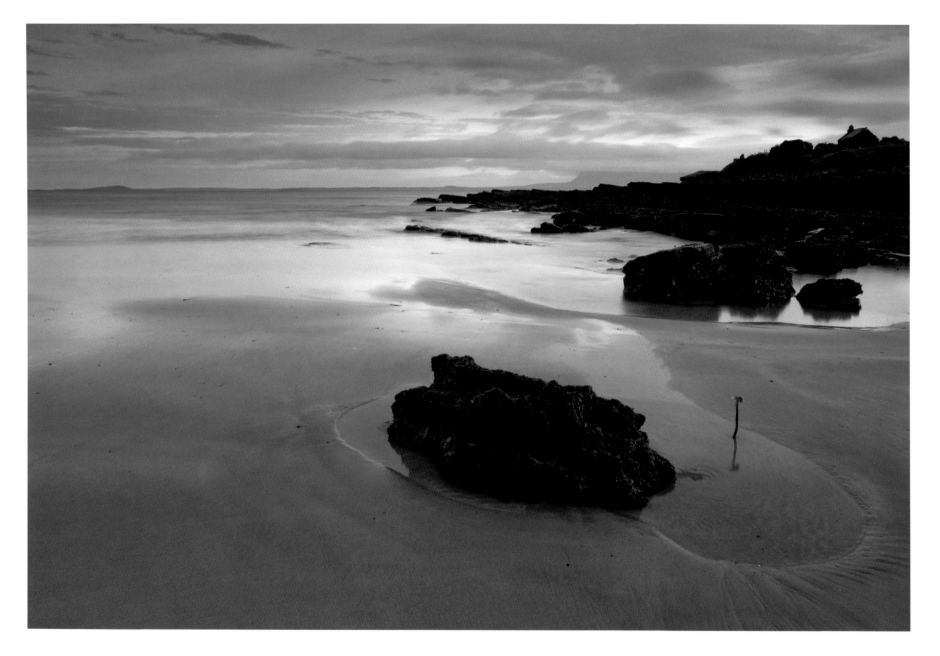

DUNMORAN BEACH
County Sligo

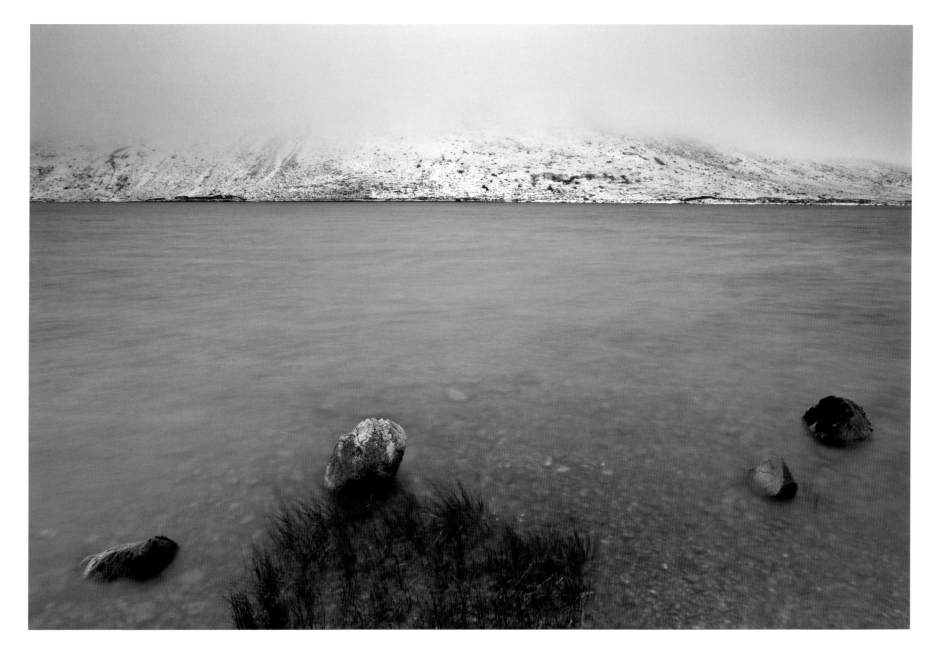

WINTER AFTERNOON
Lough Talt, County Sligo

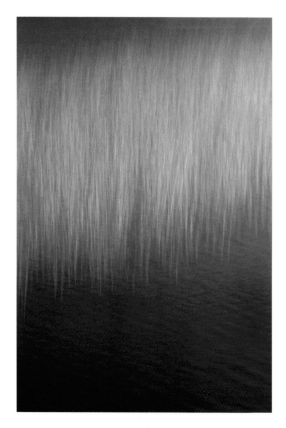

REEDS I
Doon Lough, County Leitrim

REEDS II
Glencar Lough, County Sligo

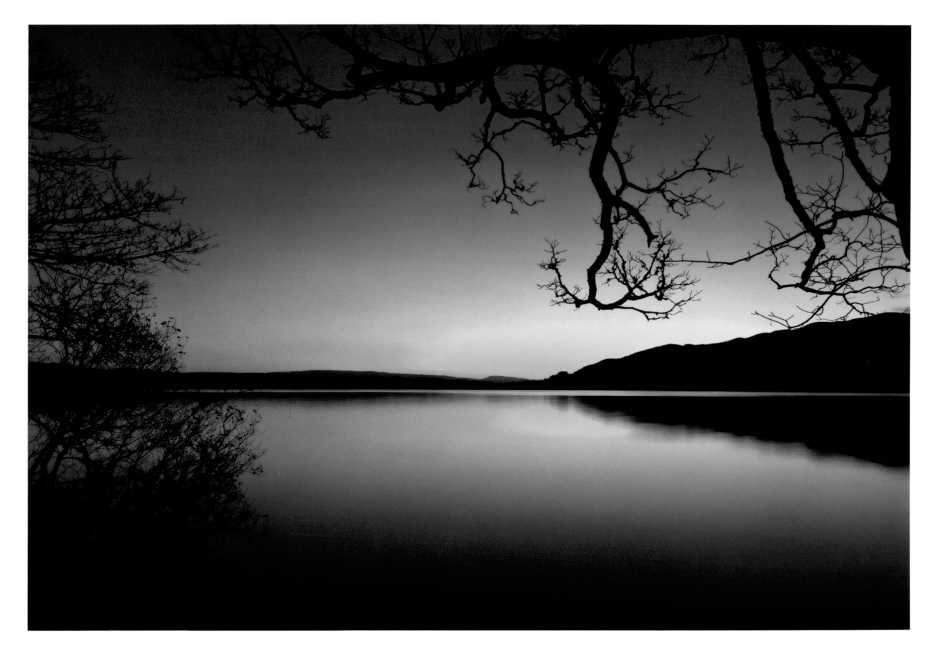

LAKESIDE WINTER DAWN
Lough Gill, County Sligo

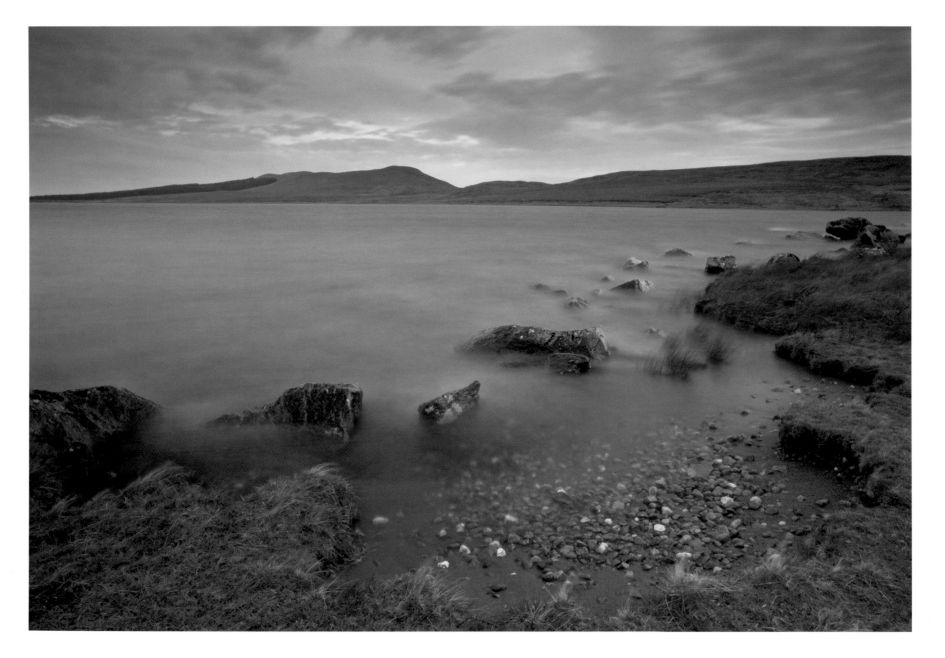

LOUGH EASKY
Ox Mountains, County Sligo

BEN BULBEN
County Sligo

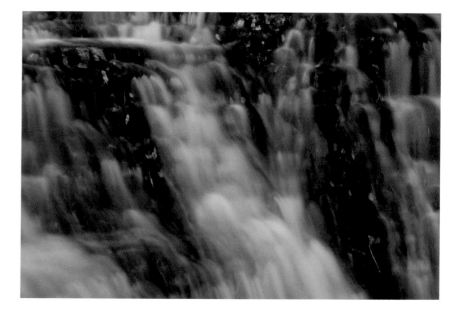

CASCADE & LEAVES
Glencar, County Leitrim

Shared by both counties are the glens of Glencar and Glenade. These two valleys are surrounded and separated by some of the most spectacular mountains in Ireland. Rivers and glaciers formed these fertile valleys and sculpted mountains with high plateaus, vertical cliffs and towers. The likes of Ben Bulben, King's Mountain, Benwiskin and Truskmore can only be described as majestic. Places like Eagle's Rock even seem to have escaped from great American landscapes like Monument Valley on the Utah–Arizona border or could be at home at Bryce Canyon, Utah. The valleys below are an enchanting series of long lakes, rivers, streams and waterfalls fringed by forests.

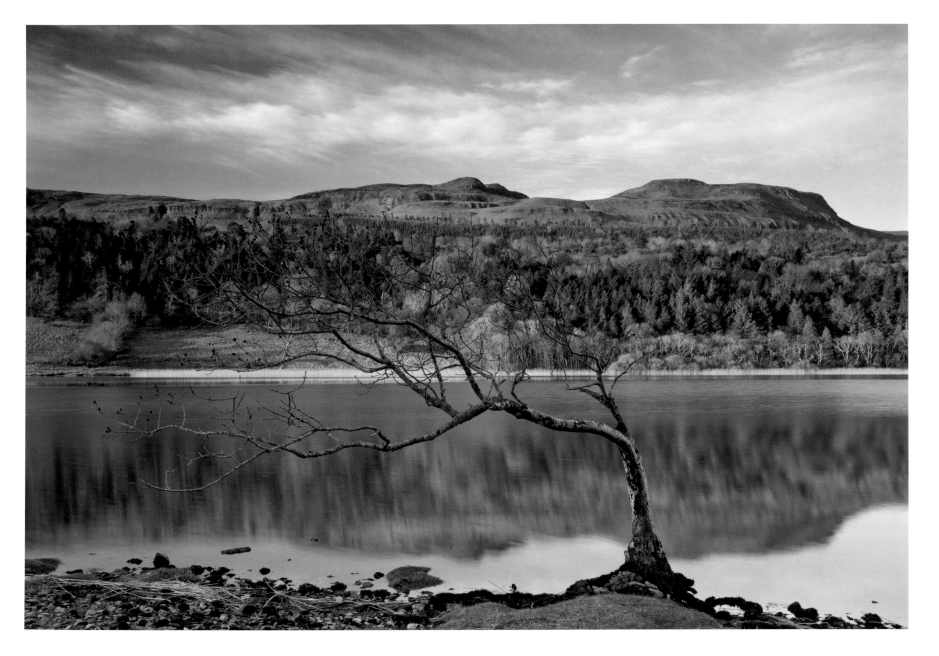

GLENCAR LOUGH
Glencar, Sligo–Leitrim border

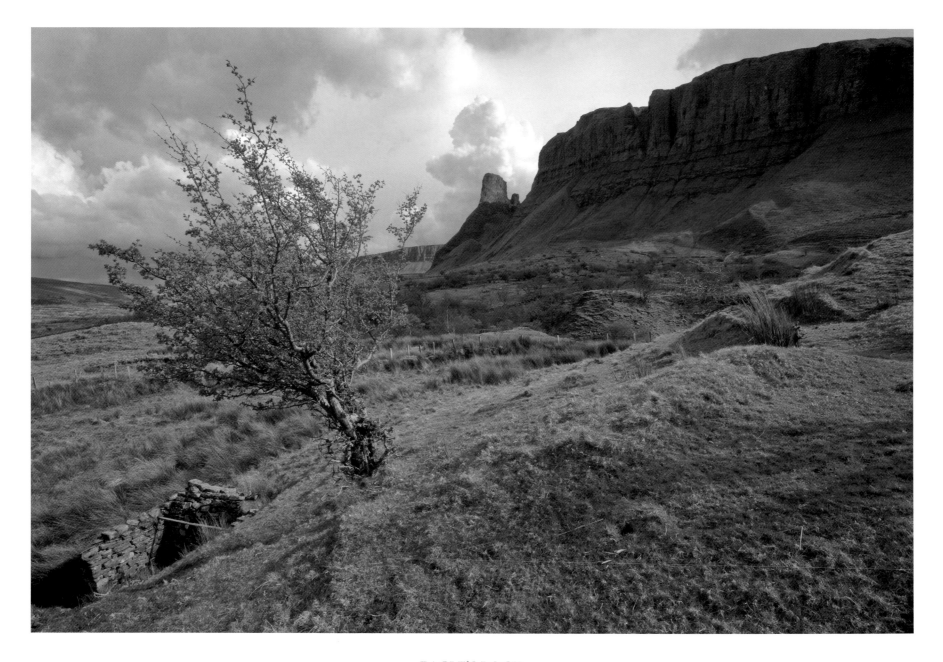

EAGLE'S ROCK
Glenade, County Leitrim

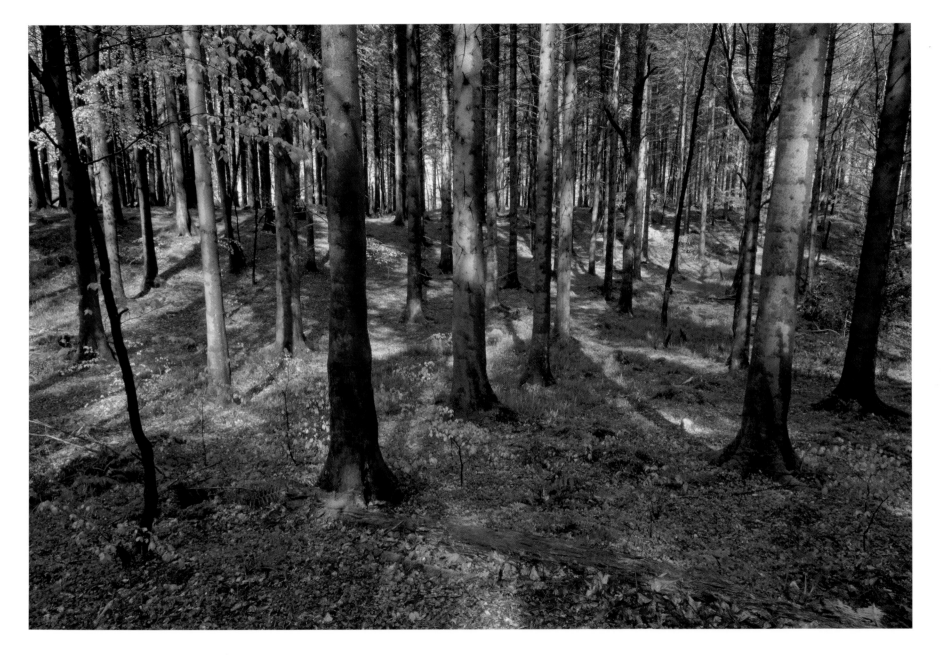

SPRING FOREST
Dooney Rock, Lough Gill, County Sligo

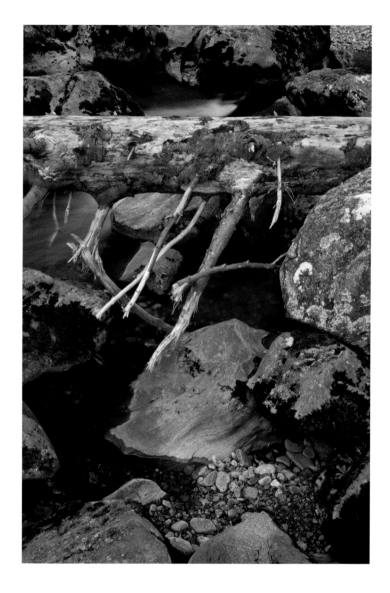

LOG, ROCKS & STREAM
Ox Mountains, County Sligo

Despite the inspiring scenery my work in Sligo and Leitrim has been difficult. Partly to blame is the weather that always seemed to send a low-pressure system the moment I had arrived. The other problem is the ubiquitous presence of barbed-wire fences and signs that declare the land private. This is not a problem only in Sligo and Leitrim but I felt more haunted by them here than elsewhere.

On one side I can understand the landowners who would like to avoid hordes of mindless ramblers wandering over their land, leaving gates open, destroying stone walls and, in the worst case, hurting themselves and suing the landowner as if their stupidity was his/her fault.

On the other side I feel that everybody has a right to experience what is left of the Irish wilderness and should be free to enter and enjoy the unpaved countryside. A solution to this problem will be hard to find or even impossible unless the government intervenes. The best the outdoor enthusiast can do is to treat the landowners and the land with respect. Regarding the weather however, I am afraid there is nothing we can do.

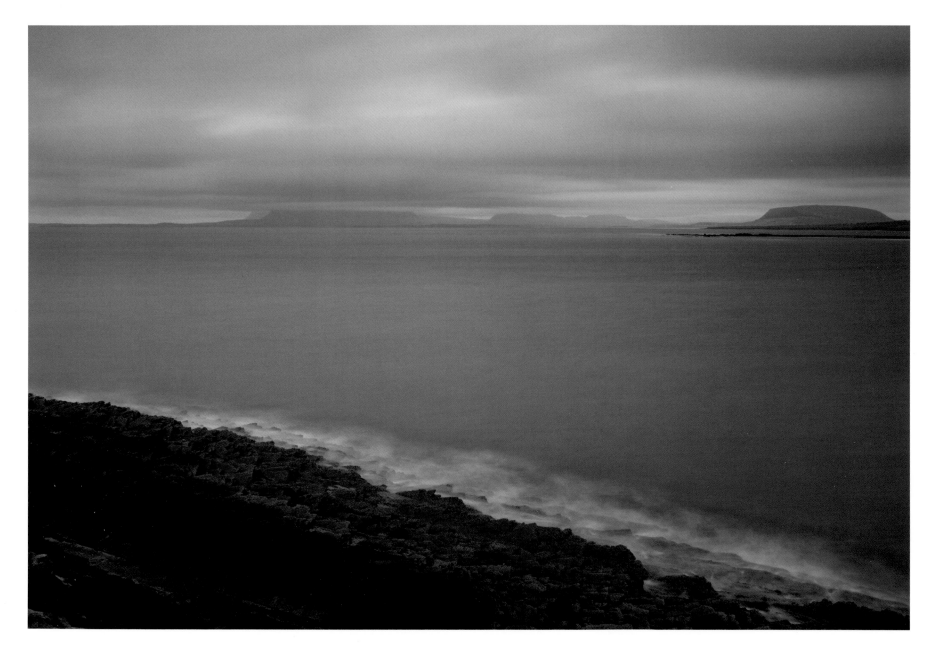

SLIGO MOUNTAINS
Ben Bulben, King's Mountain, Knocknarea (l-r) from Aughris Head, County Sligo

Acknowledgements

This book is not meant to be a tour guide or a source of information but merely a journey of inspiration and visual stimulation. To learn more about Ireland's west there are several books that I found helpful and entertaining on my travels. Michael Viney's *Ireland* gives a comprehensive overview of Ireland's natural history and Mike Harding's *Footloose in the West of Ireland* pointed me in the right direction more than once. Tim Robinson's *Connemara* was not only an overwhelming source of stories and history, it also made the waiting for the light more enjoyable. The *Discovery Series* maps of OS Ireland were the perfect companions to find my way there and back again.

This book would have not been possible without the help and support of many individuals who all contributed in their own way. My sincerest thanks go to The Collins Press; to Marcel Otten at Man Made Images for putting his heart and soul into promoting the fine art of photography, and to my personal heroes Paul Wakefield, Joe Cornish and Jim Brandenburg for their inspirational work.

I also would like to thank Margaret and Kevin at the Diamond Rocks Cafe in Kilkee for their support. For making me feel at home on my travels I would like to thank Rachel & family in Camp, Patricia & family in Kenmare and Anne & family in Crossmolina.

A very personal thank-you goes to Thomas for being a true friend over time and distance. And finally to Ina and Jonah for supporting my dream and tolerating my regular physical and psychical absence.

Fine Art Prints

You can order fine art prints and find more information about the author on Carsten Krieger's website: www.carstenkrieger.co.uk